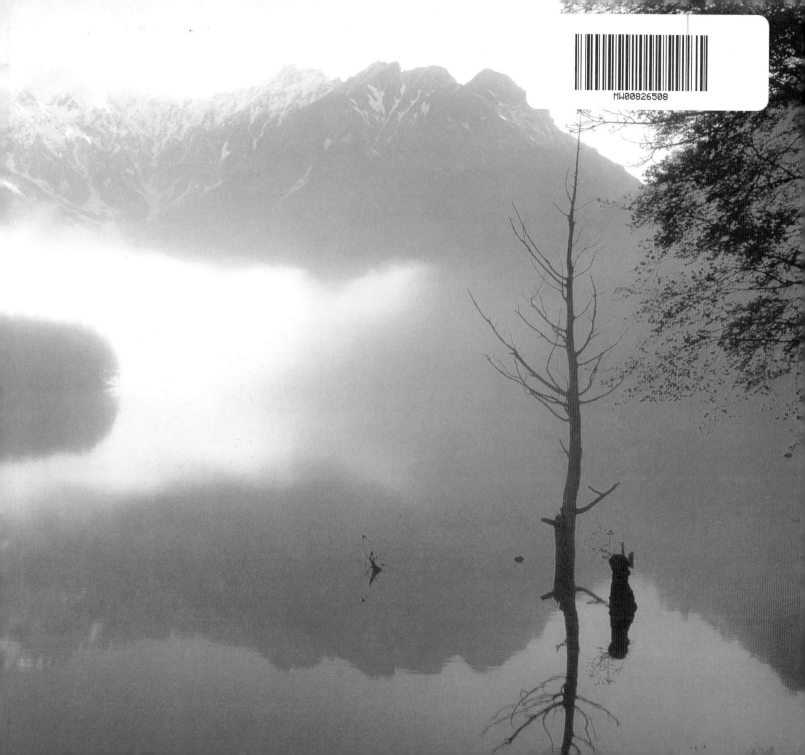

Translator/Zachary Braverman
Supplementary Research/Akemi Wegmüller

Editor in Chief/Hyoe Narita
Publisher/Seiji Horibuchi

Originally published as Wanorakuen by Shogakukan, Inc. in Japan.
Editor/Atsushi Takahashi
Art Director/Yukimasa Okumura

Printed in Hong Kong

ISBN 1-56931-499-3

First printing, October 2000

Cadence Books
A division of Viz Communications, Inc.
A subsidiary of Shogakukan, Inc.
P.O. Box 77010, San Francisco, CA 94107

EQUIPMENT	
Camera:	PENTAX 645 N
Lenses:	PENTAX 35mm F3.5
	PENTAX 45~85mm 200M F4.5
	PENTAX 120mm MACRO F4
	PENTAX 300mm ED F4
Film:	FUJICHROME VELVIA/PROVIA/ASTIA

JAPAN PARADISE

A PHOTOGRAPHIC JOURNEY TO JAPAN'S MOST EXQUISITE RESORT HOTELS AND INNS

KAZUYOSHI MIYOSHI

CADENCE BOOKS

Mon chér Japon

Je viens au Japon depuis mon enfance.

Ma mère, qui était pianiste, et mon père, architecte (tous deux français) vivaient à Shanghai mais allaient périodiquement passer leurs vacances d'été au Japon. Ils aimaient particulièrement le KYUSHU.

Je me souviens, avec nostalgie, des merveilleux moments passés à jouer le long de la grande plage, bordée par l'immense forêt de pins de NISHNO-MATSUBARA, avec les fils des pêcheurs locaux, et à plonger avec les enfants des amis dans les eaux cristallines des "SEPT GROTTES" (NANATSUGAMA).

C'est dans leurs alentours que j'ai rencontré, sur l'eau, mes premiers dauphins! Oh!... combien j'aimais déjà la Mer et la Nature de ce pays enchanteur! Mes parents savouraient l'ambiance très unique des grands "RYOKANS" tels que l'AZUMAYA HOTEL — qui n'existe plus — et le MATSUBARA HOTEL, qui ressemble de plus en plus à un fantôme!

De nos jours, lorsque je vais à Karatsu, je continue à revivre mes souvenirs d'enfance, en "m'installant" à proximité du Vert (de la forêt de pins) et du Bleu de la Mer, au KARATSU SEASIDE HOTEL géré par mon bon ami KENJI OTANI. J'y retrouve une atmosphère savamment mitigée de décor intérieur à la fois Oriental et Occidental, que j'apprécie beaucoup.

Mon père Laurent Mayol adorait peindre (surtout de l'aquarelle) et c'est en l'observant et en le suivant au cours de ses nombreuses randonnées aux quatre coins du pays que j'appris à en aimer toute la Beauté.

Je pense que sa plus grande richesse est la diversité de ses paysages, réunis sous un même "toit", de surface relativement moyenne.

En peu de kilomètres les décors passent, par exemple de profils montagneux — parfois austères — à un relief de rivières en terrasses ou de falaises escarpées tombant sur des criques rocailleuses. Ou alors, ce sont les denses forêts et les plages que survolent les légions d'oiseaux.

On dirait qu'ici "Mère Nature" a voulu rassembler très près les uns des autres tous ces "éléments de Beauté" qui, dans d'autres pays, sont beaucoup plus espacés!

Je pense qu'il faut tout dire et <u>Tout faire</u> pour encourager le Japon à protéger cette nature si délicate.

Depuis quelques années je m'y déplace beaucoup. Dans mon choix d'hôtels, j'opte presque toujours pour le traditionnel ryokan. Pour moi, il reflète et symbolise tout l'Esprit, la Culture, la Magie et l'Histoire du peuple Japonais, que l'on retrouve ainsi dans l'expression des moindres détails.

Et puis... je préfère de loin l'odeur du bois et du tatami à celle du béton! Un de mes ryokans favoris est le

YOYOKAKU, de Karatsu, dont vous verrez d'ailleurs les magnifiques photos dans ce livre. Je raffole de son authentique architecture, de son ambiance et de son jardin traditionnel... et de la cérémonie du thé en compagnie de mes hôtes et amis HARUMI et "DAN" OKOCHI.

Je dis souvent que si, pour une raison indépendante de ma volonté, je ne pouvais plus me déplacer à ma guise — comme je le fais, et devais me cantonner en un seul lieu, je choisirais sans hésiter le Japon!

De l'intense froid hivernal de l'HOKKAIDO aux chaleurs quasi-tropicales des îles du Sud, ce pays réunit tous les climats que j'aime.

Et je ne m'étendrai pas sur le choix des différentes formes de Culture, d'Art, de Musique... qui dépasserait le cadre de ce qui devrait être une courte préface, que j'écris d'un "premier jet", du fond du cœur, en témoignage de l'amour sincère que je porte au Japon.

Je souhaite à ce Maître de la photographie qu'est Monsieur KAZUYOSHI MIYOSHI, tout le succès que mérite son admirable ouvrage.

Jacques Mayol
(TATEYAMA-CHIBA — 1998)

Mon Chér Japon

Japan has always been close to my heart. When I was a child, I lived in Shanghai with my architect father and pianist mother, and we spent every summer vacationing in Japan. We liked Kyushu the best. I will never forget the endless pine trees of the Niji-no-Matsubara, the "Rainbow Forest," or my days playing with fishermen's children on the beach or searching for the Nanatsugama Caves in the bright, clear sea.... I still remember the first time I saw dolphins, from the sand dunes above Karatsu Bay on the Matsubara Coast.

Oh, how I loved the sea and everything nature had to offer in that charming place!

Shunning Western accommodations, my parents always took lodgings at Japanese inns. I was enchanted by the mysterious atmosphere of the Azumaya and Matsubara Hotels. "There aren't any hotels like this anywhere else in the world," my father would declare again and again.

Even now, when I return to Karatsu to gaze at the pine groves or immerse myself in the wide, clear sea, it brings me back to my youth. The only thing that has changed is that the Azumaya and Matsubara Hotels are gone. My friend Kenji Otani, with whom I stay, resides permanently at the Karatsu Seaside Hotel. I relish the atmosphere there—a flawless blend of Eastern and Western influences.

I spent the summer days of my youth walking endlessly through Japan in search of new scenes for my father to paint in the watercolors he loved. The astounding variety of landscapes that coexisted so close to each other under the same, small sky filled me with wonder. Within only a few kilometers, mountains gave way to rice fields that became steep cliffs that transformed into inlets that led to sand dunes. And there were also deep forests and lonely beaches with only birds to keep them company.

Japan is so tightly packed with every conceivable aspect of beauty that they can't help but blend into one another. This is not the case in other countries, where one needs to travel long distances to encounter a complete change of scenery. I fervently believe that we must employ every measure available and spare no effort to preserve the unique and delicate nature of Japan.

Of late, I have been returning to Japan more and more frequently. Of course I choose to stay in Japanese inns, for these buildings reflect Japan's spirit, its people, and its history. And I feel more comfortable surrounded by the smells of tatami and wood than of concrete.

One inn which I particularly cherish, Yoyokaku, is featured in this book. The architecture of the building truly reflects the Japanese spirit, and its gardens are magnificent. This inn possesses a unique quality that no amount of writing can express. Sitting down to tea there with the owners, Mr. and Mrs. Okochi, restores strength to my heart, weary from travel.

I have always told my friends around the world that when I get too old to travel anymore, I plan to settle down in Japan. Japan encompasses all the climates I love, from the severe cold of Hokkaido winters to the tropical warmth of the southern islands. The depth of my love for Japan could never be expressed in this short introduction, so I will have to hope that Mr. Kazuyoshi Miyoshi's wonderful photographs convey all the beauty of Japan that I treasure.

Jacques Mayor
"Chiba Tateyama"
1999

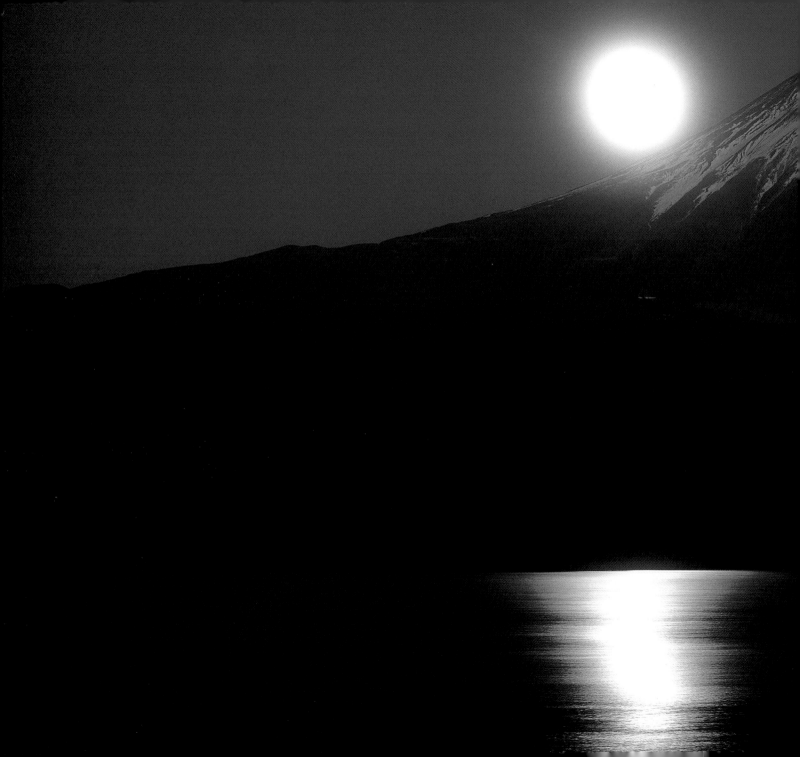

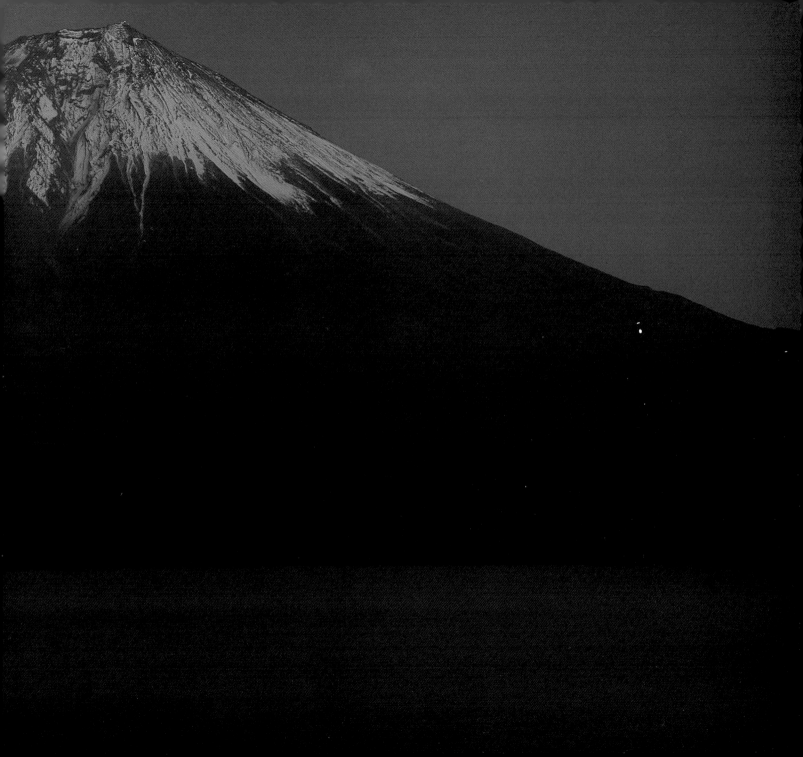

Hakone
Fujiya Hotel

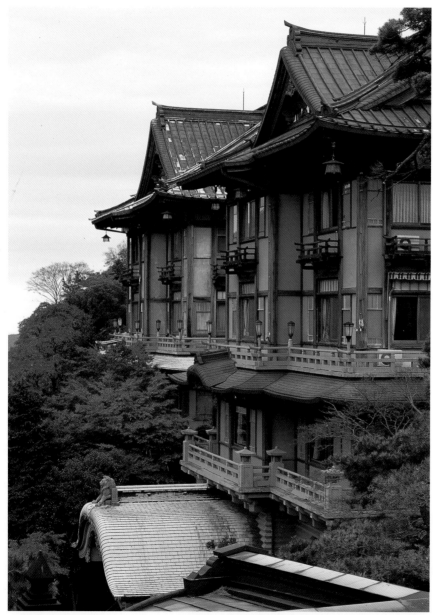

6

Ornate exterior

(Previous Pages) Full moon rising above Mt. Fuji and Tanuki Lake

Room 352,
Chrysanthemum Suite

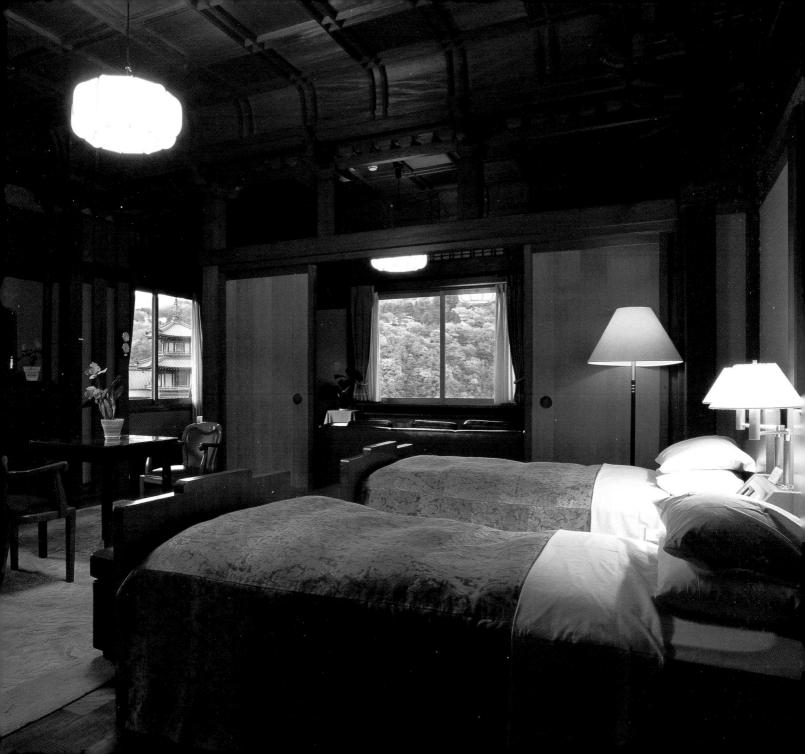

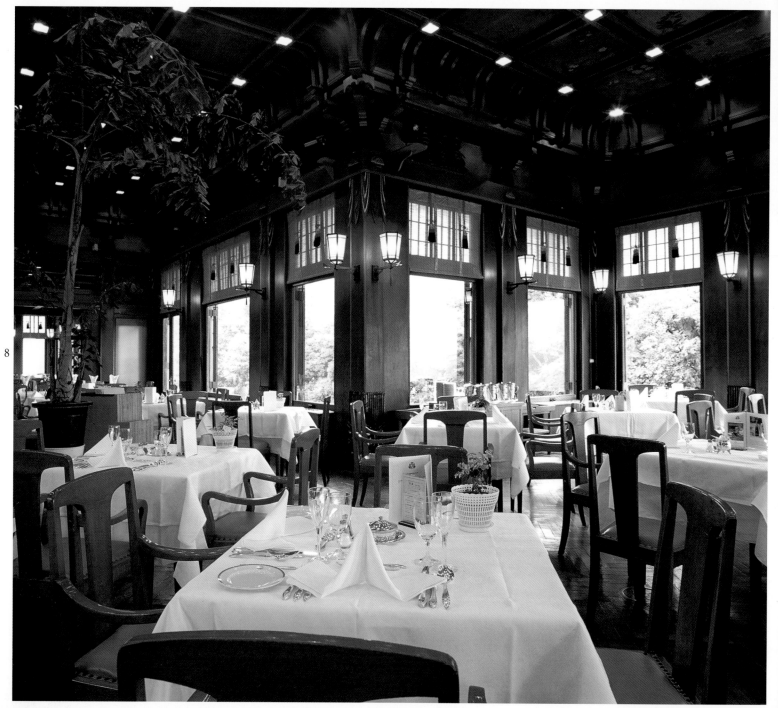

8

Fujiya Hotel dining room

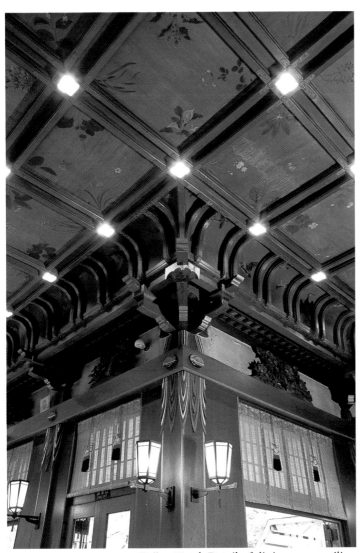

Fujiya Hotel: Detail of dining room ceiling

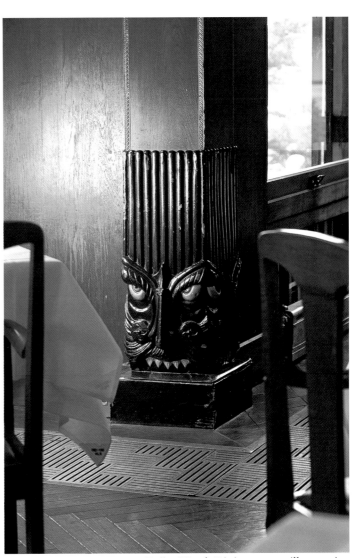

Fujiya Hotel: Dining room pillar carving

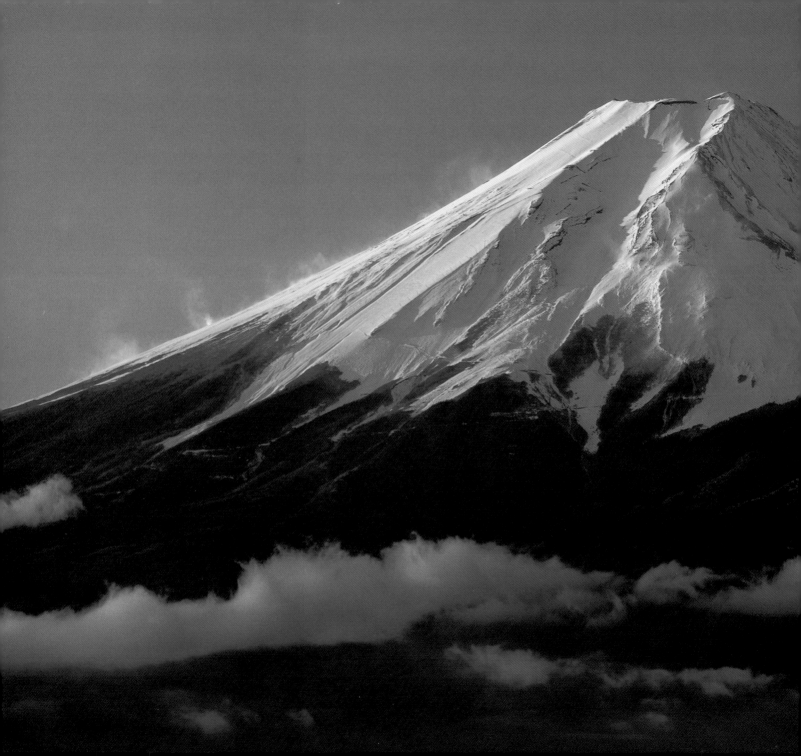

Mt. Fuji at dawn, viewed from
Mitsu-Toge Mountain Villa

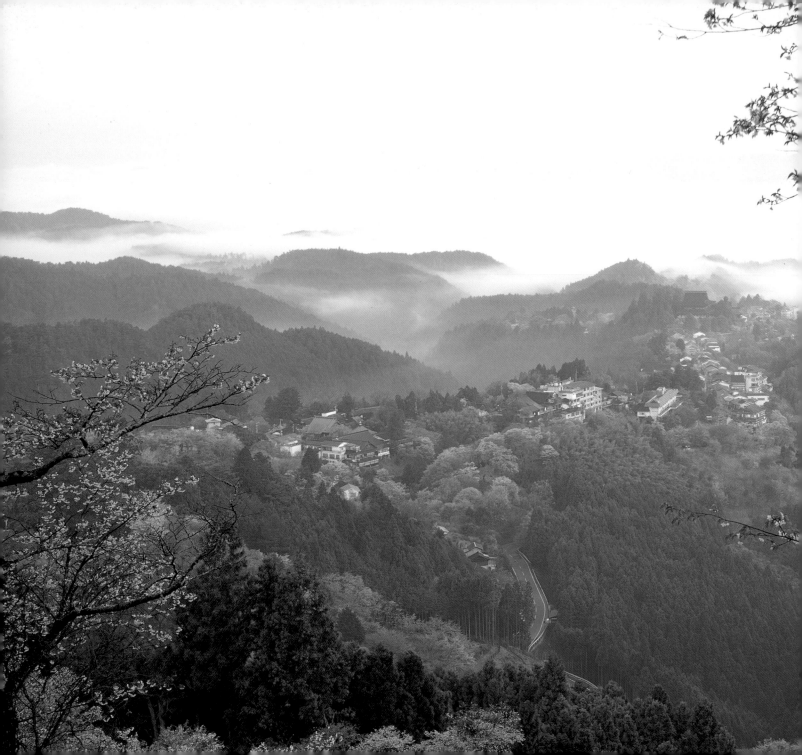

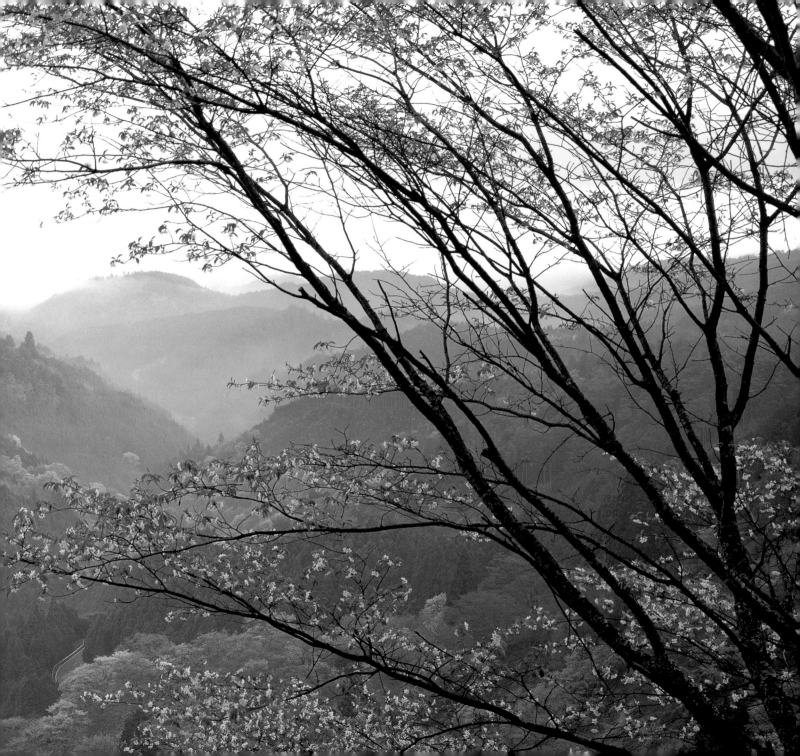

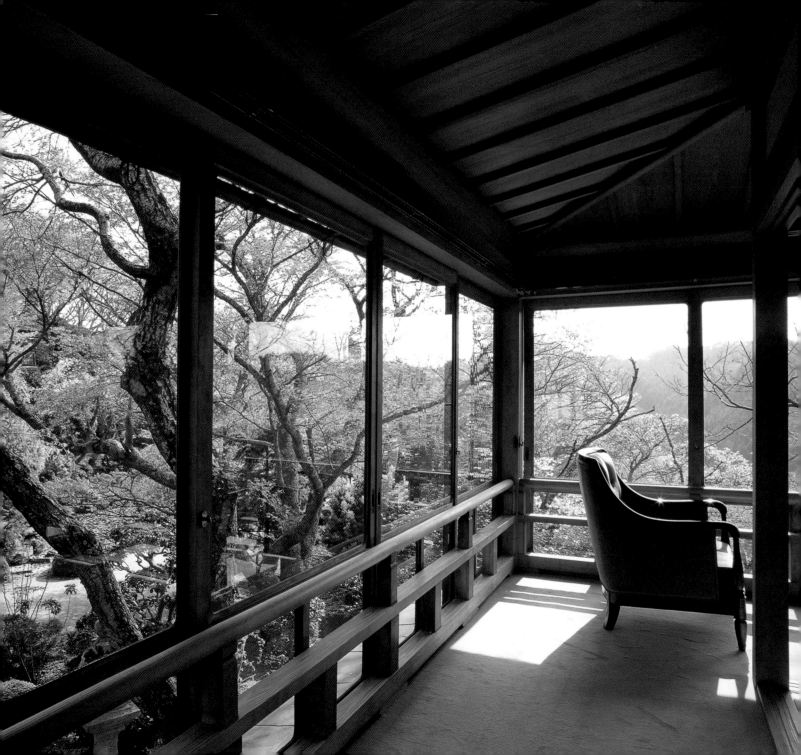

Chikurinin Gunpoen

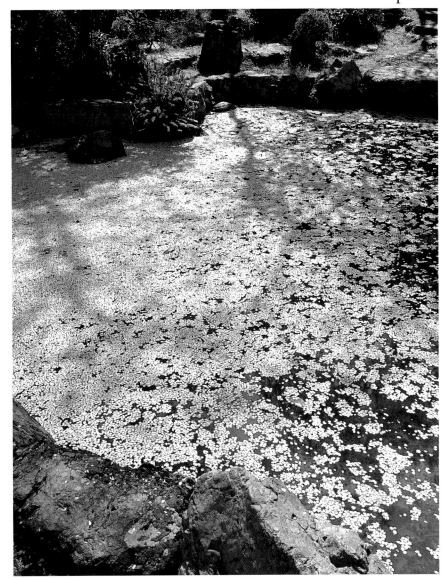

(Previous Pages) Mist covering the Yoshino hills at sunrise, viewed from Kami Senbon

(L) Pine Suite

Fallen cherry blossoms covering Gunpoen Pond

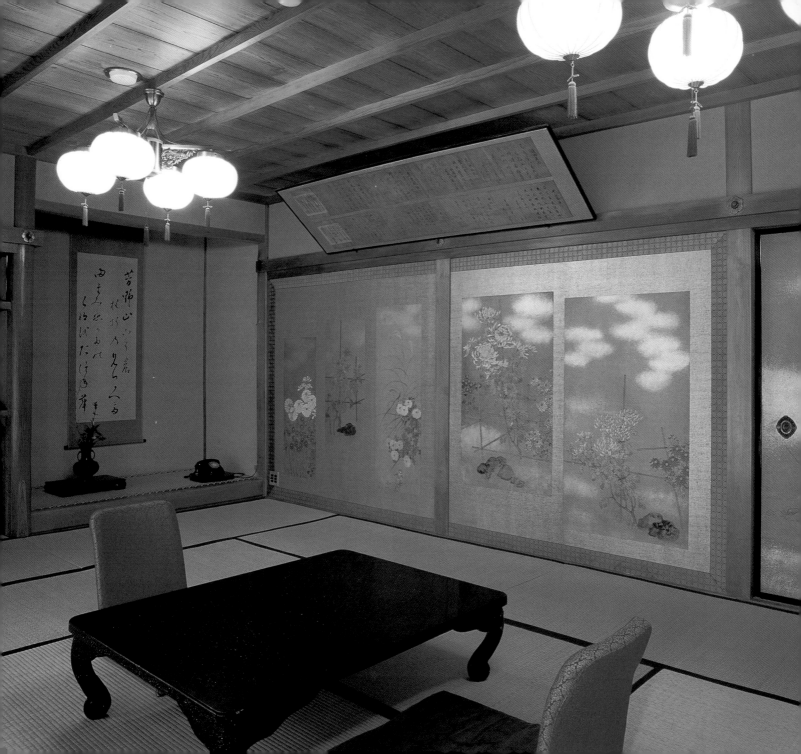

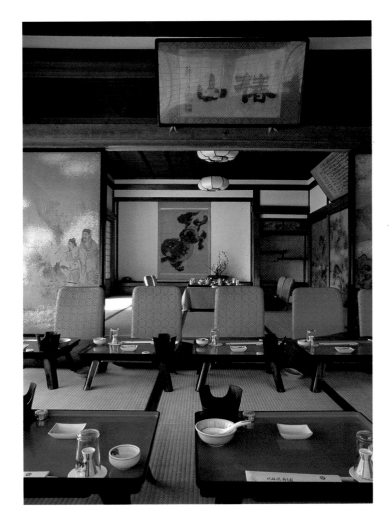

(L) Chikurinin Gunpoen: Sansui Room
(R) Bento box that Hideyoshi, famed sixteenth-century
 leader of Japan, used while flower-viewing

Chikurinin Gunpoen: Chrysanthemum Suite

18

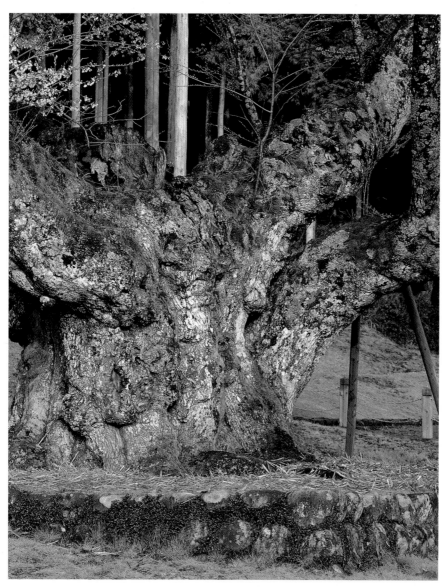

Usuzumizakura of Gifu Prefecture, Neo Village

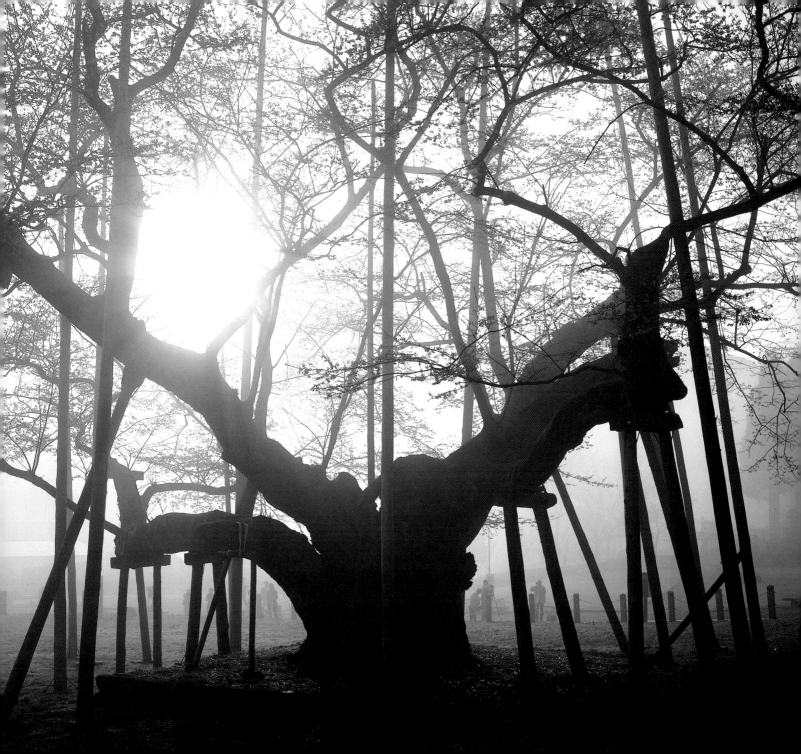

Hidatakayama
Wa-no-Sato

20

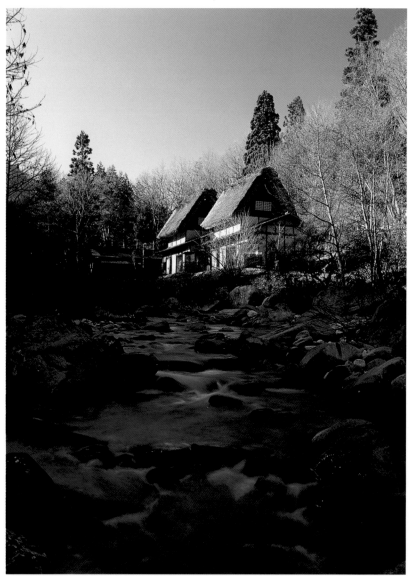

Annex room, viewed from across the Miya River

Annex Tenryo Suite

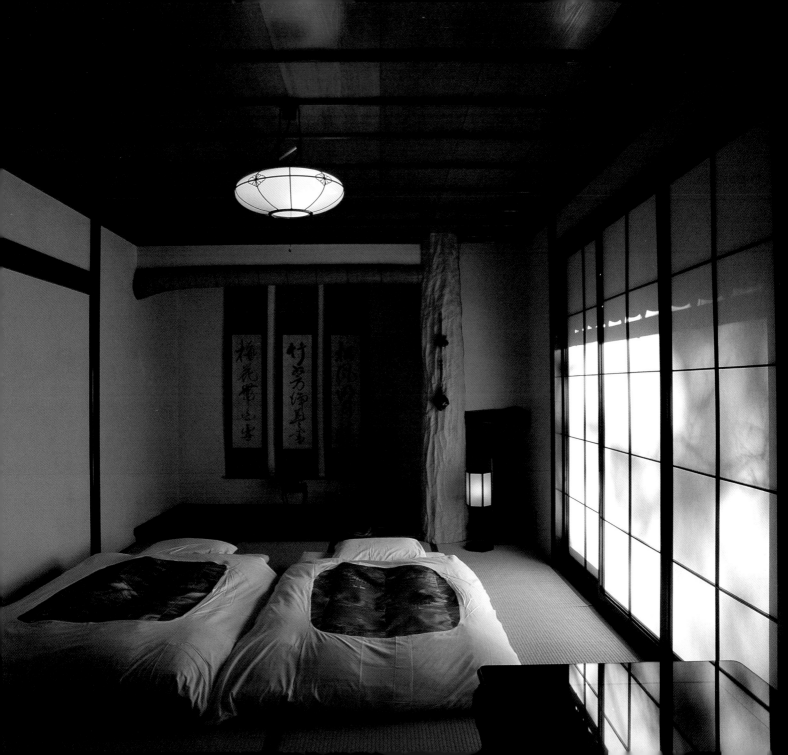

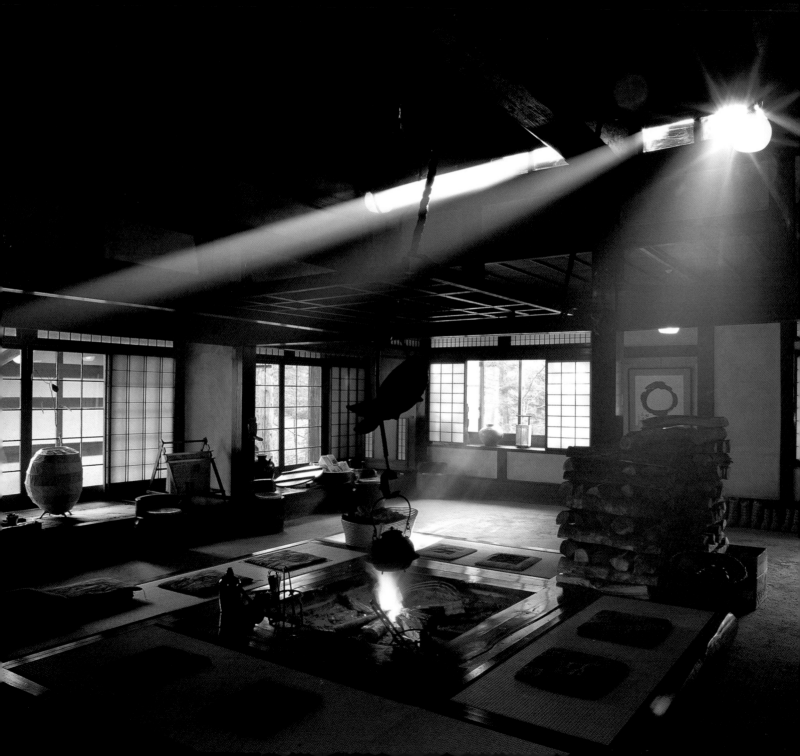

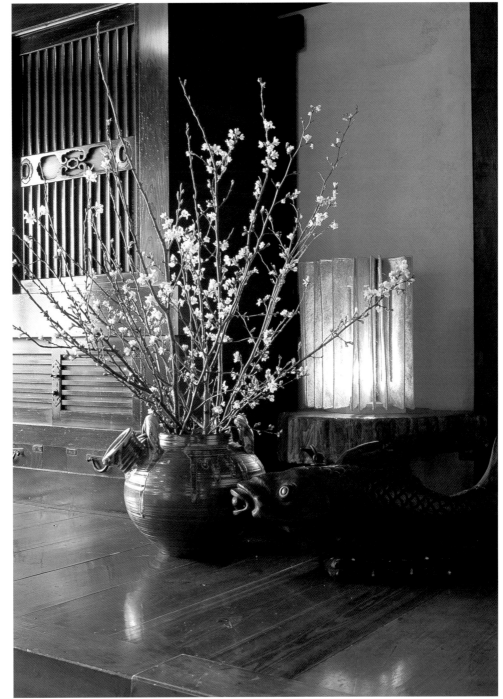

23

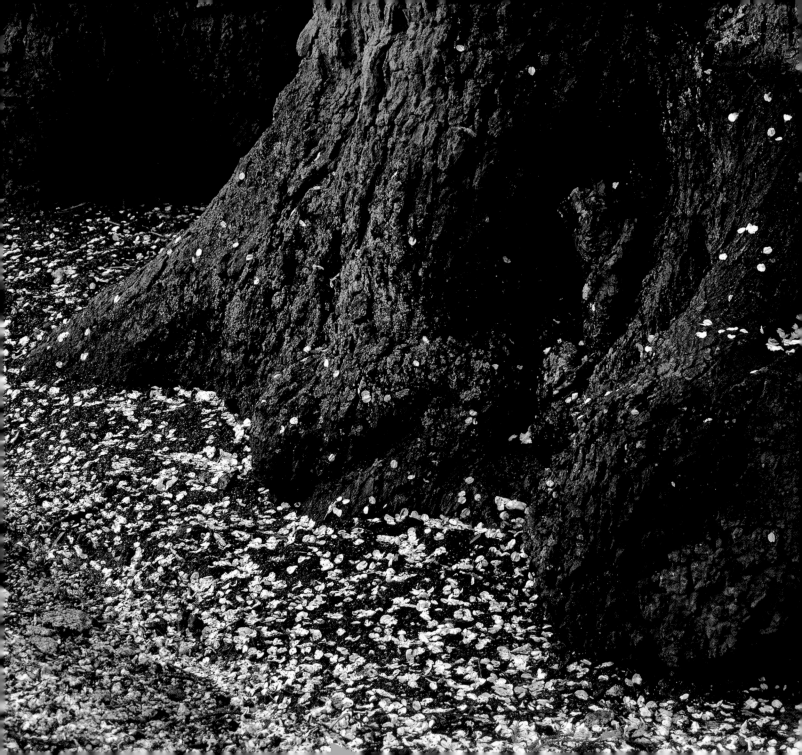

Yamanashi Prefecture,
Mukawa Village:
Yamataka Jindaizakura

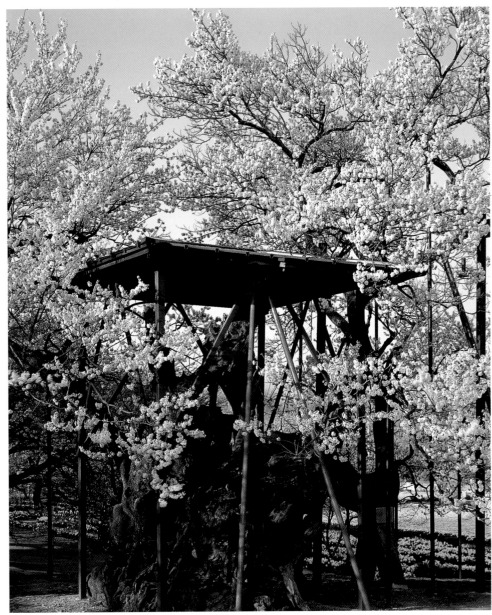

The branches of Edohigan cherry tree "Yamataka Jindaizakura" extend to a diameter of 31 meters.

Shimosuwa
Minatoya

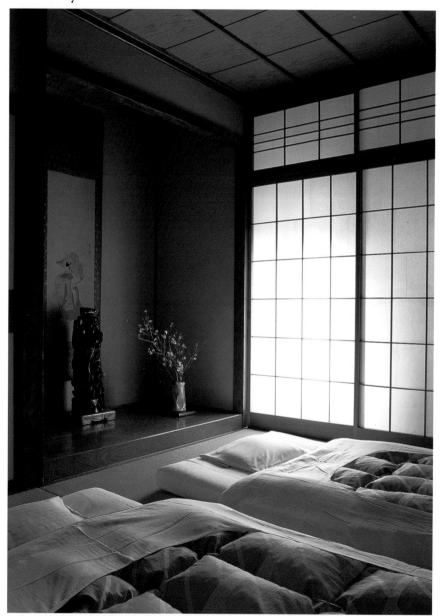

Minatoya: Guest room

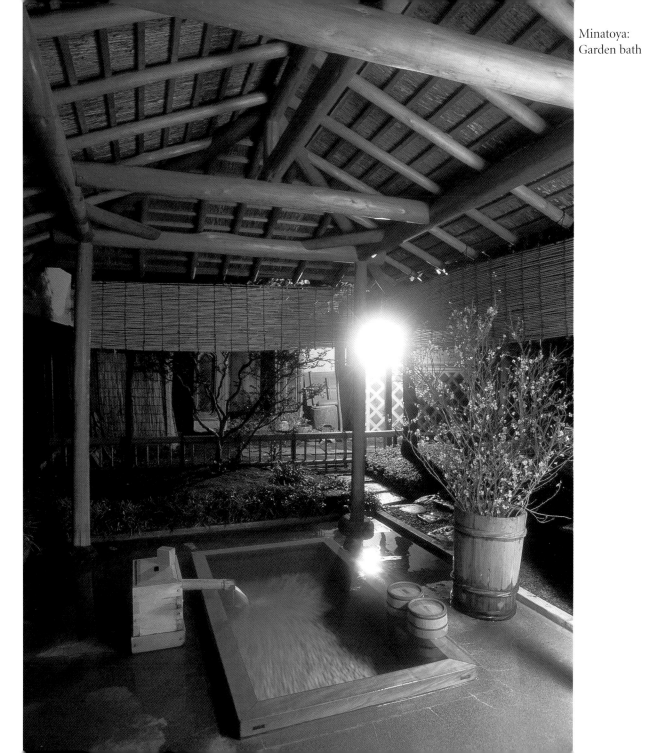

28

Minatoya: The garden bath is just the right temperature.

Minatoya: White pebble bath

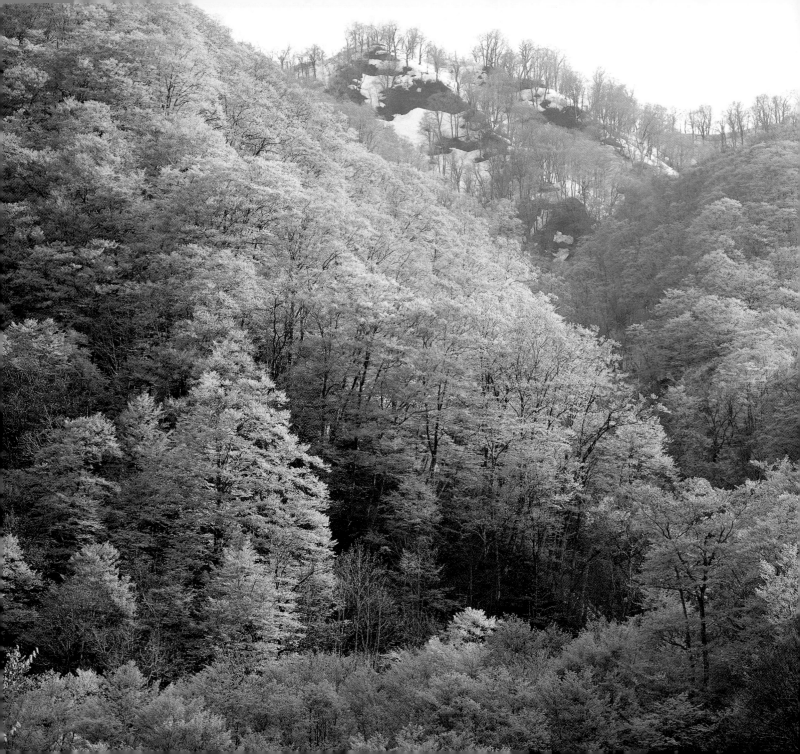

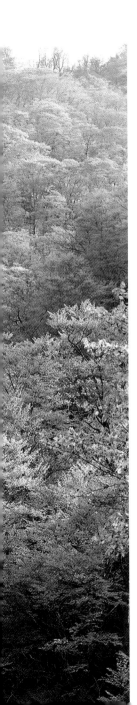

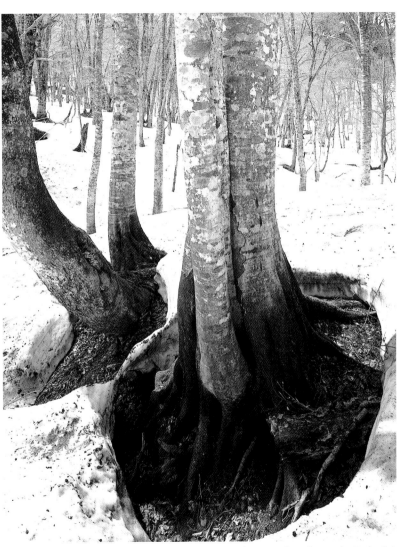

Shirakamisanchi: Spring growth near a beech tree in Dakedai

Akita Nyuto Onsen-kyo
Tsuru-no-Yu Onsen

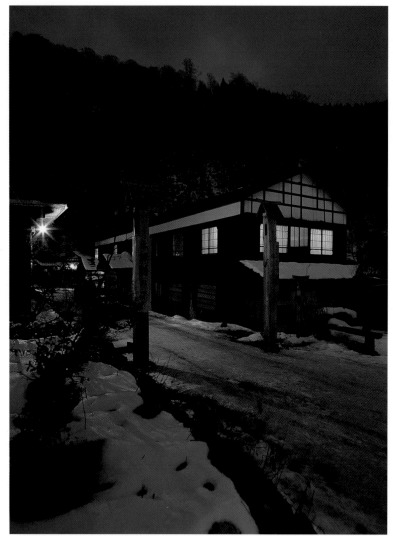

The inviting entrance

Outdoor mixed bath in the early morning

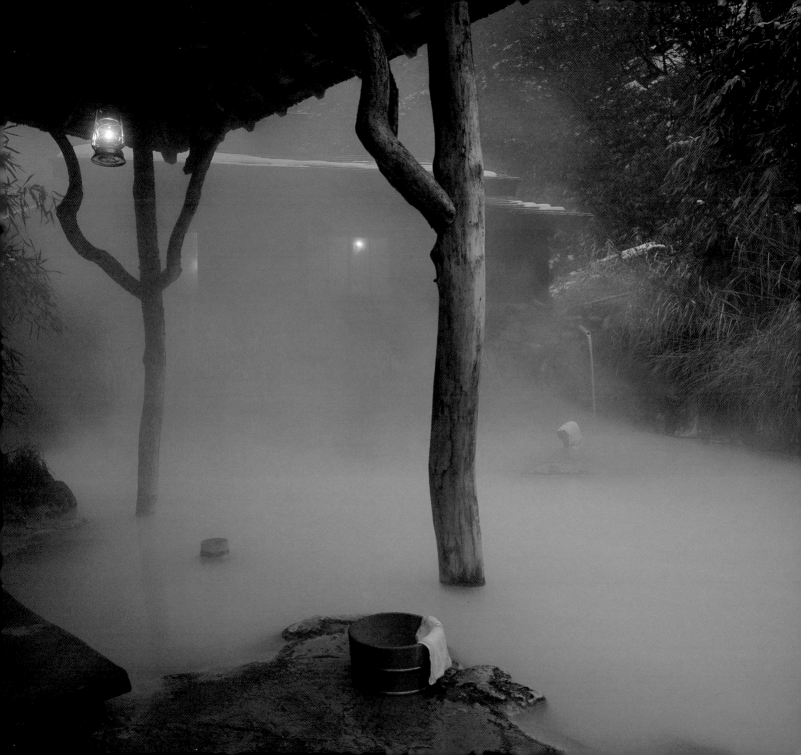

Aoni Onsen

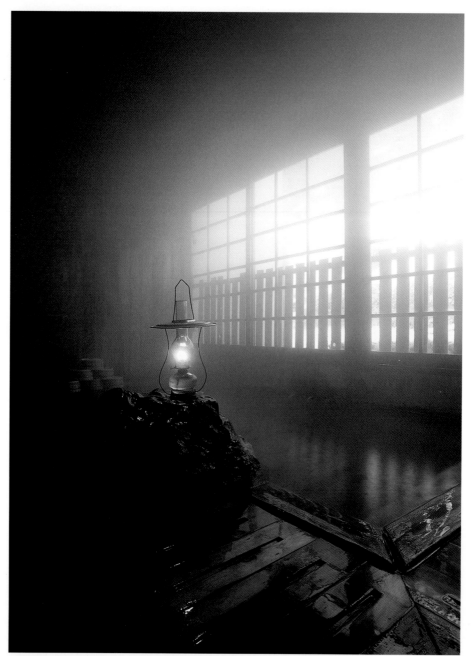

Indoor women's bath, built entirely of Japanese cypress

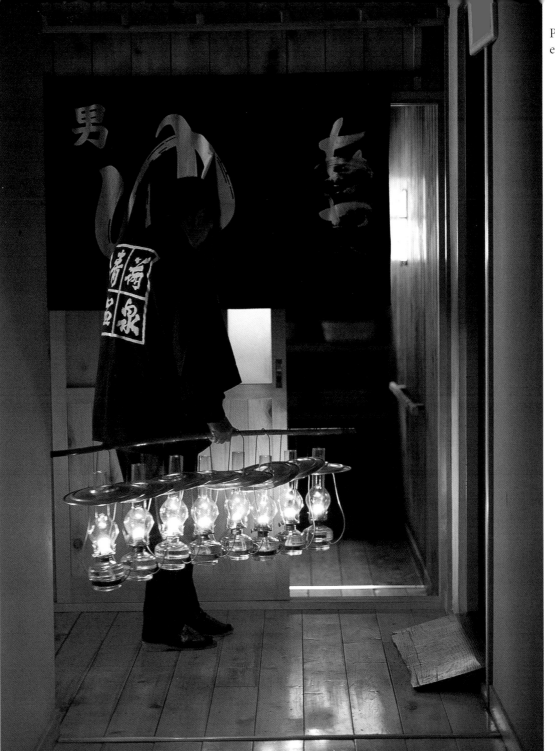

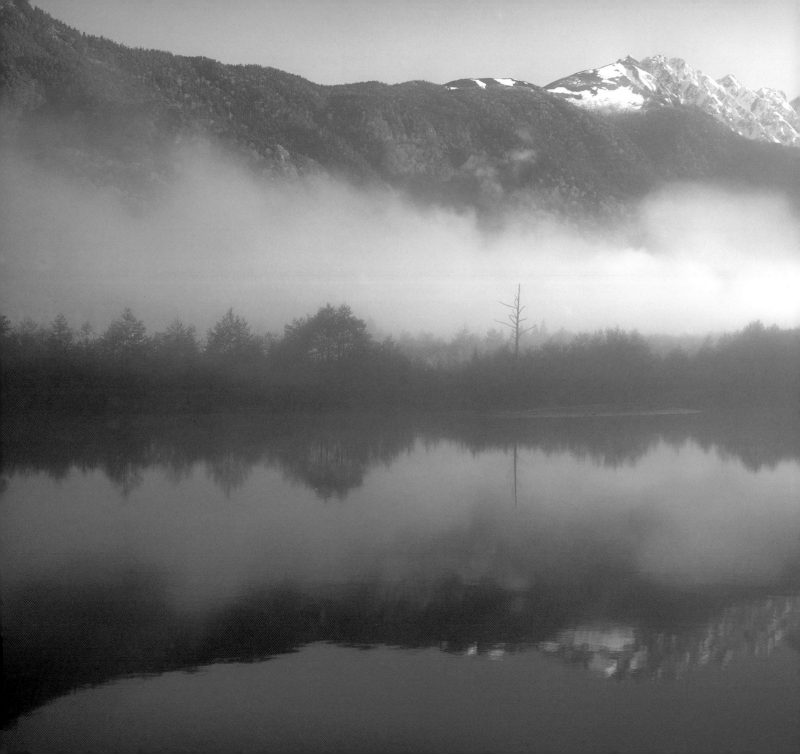

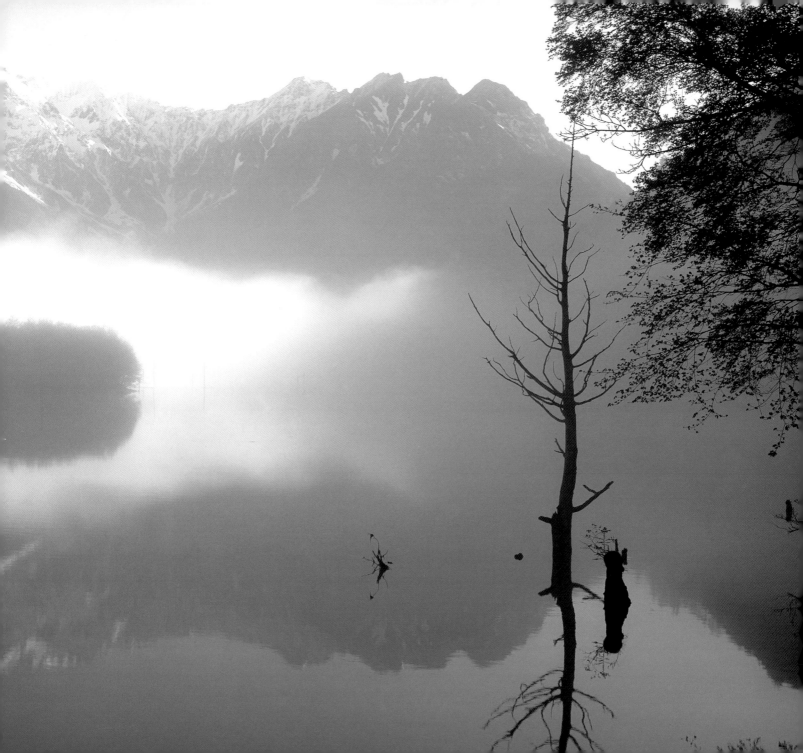

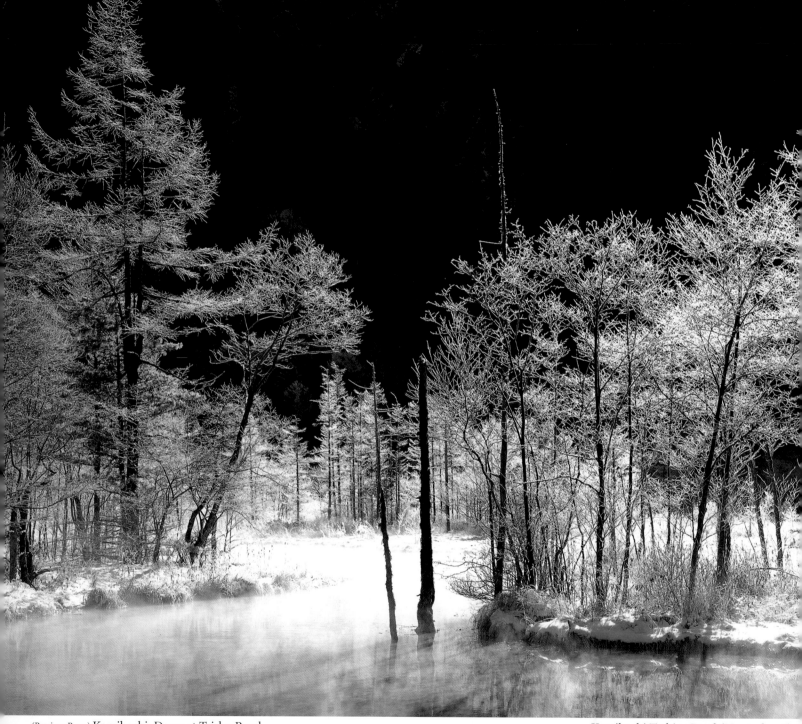

(Previous Pages) Kamikochi: Dawn at Taisho Pond

Kamikochi Tashiro Pond (November 2)

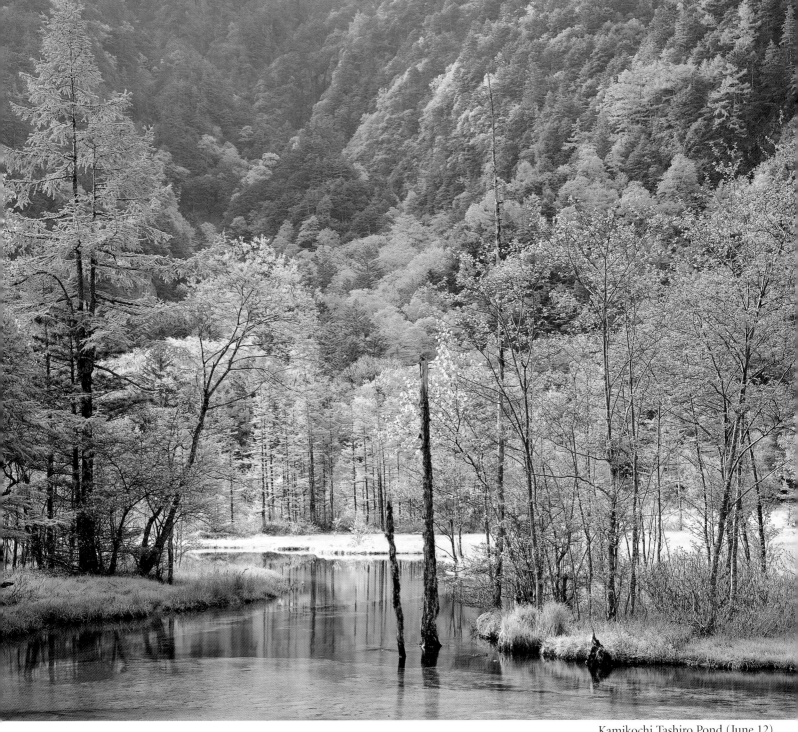

Kamikochi Tashiro Pond (June 12)

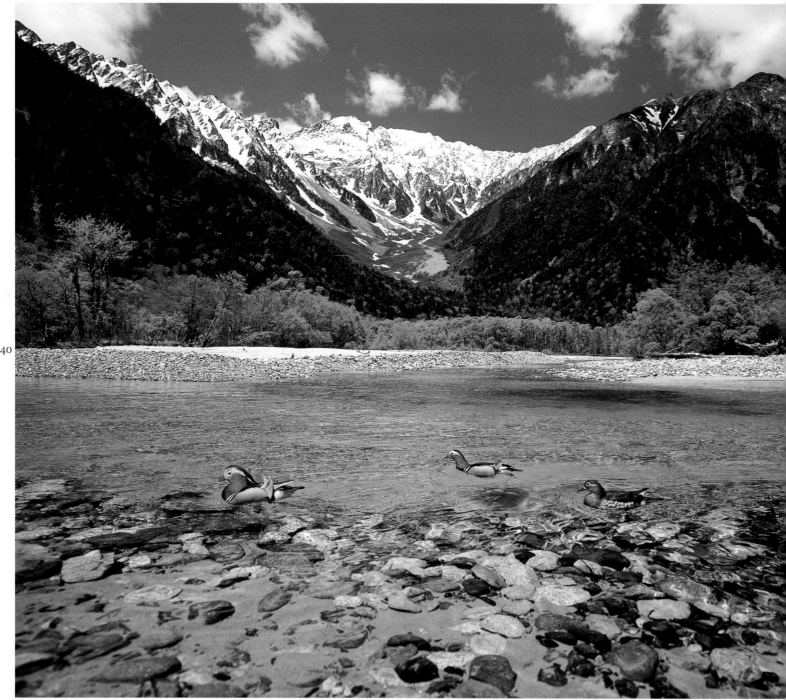

40

Hodaka mountain range, viewed from near Kappa Bridge

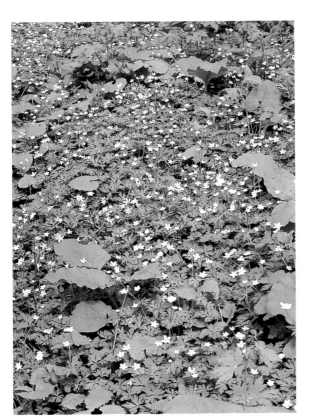

Kamikochi Imperial Hotel

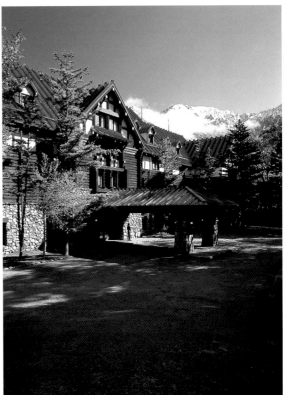

(L) Wild buttercups
(R) The entrance in the early morning

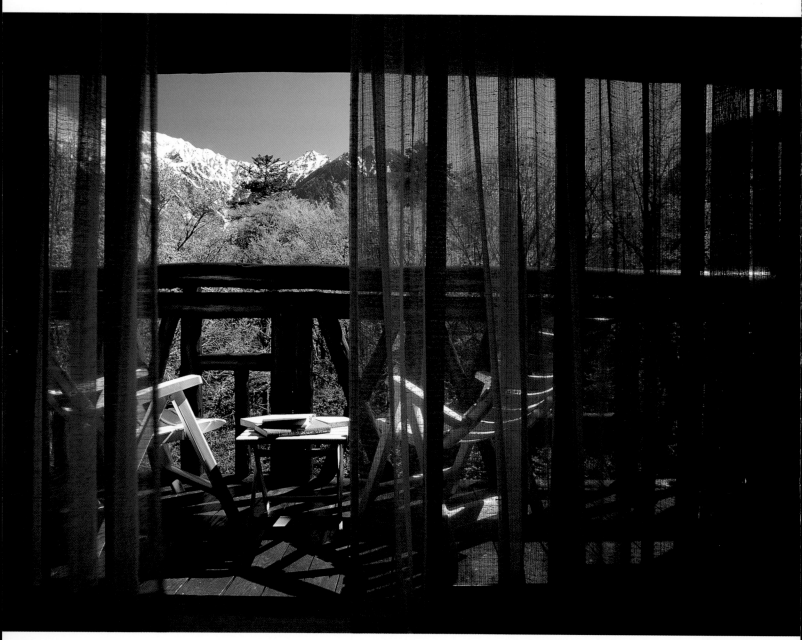

Kamikochi Imperial Hotel: View from the Family Suite

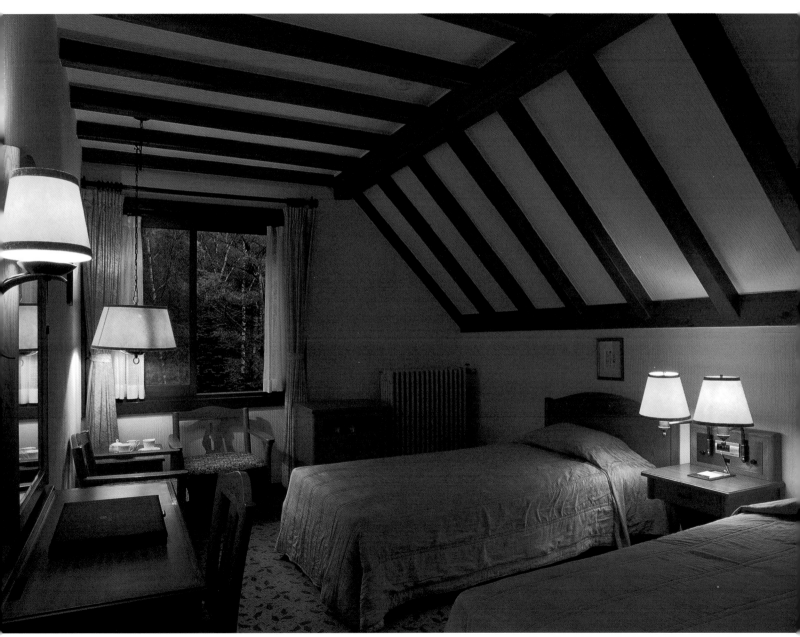

Kamikochi Imperial Hotel: Standard twin room

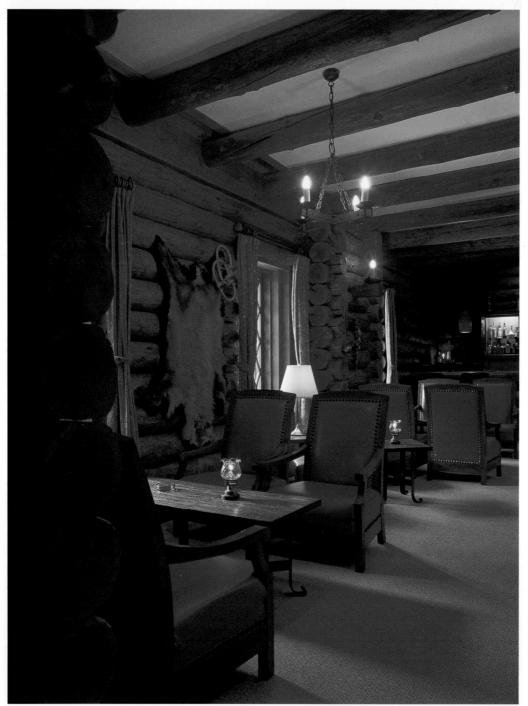

44

Kamikochi Imperial Hotel: Bar

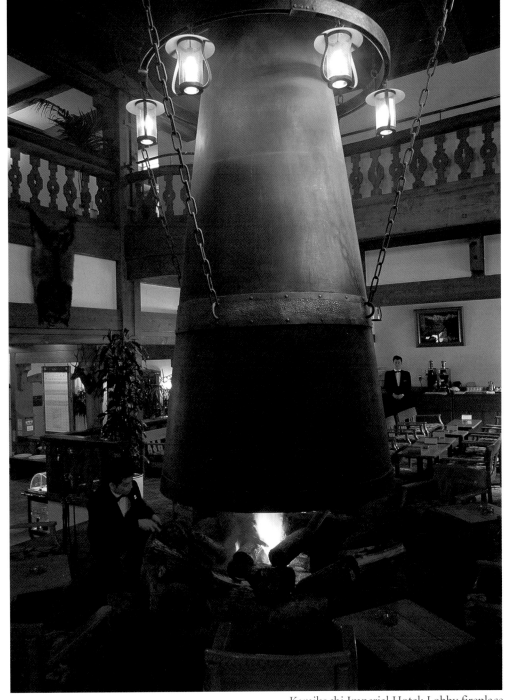

Kamikochi Imperial Hotel: Lobby fireplace

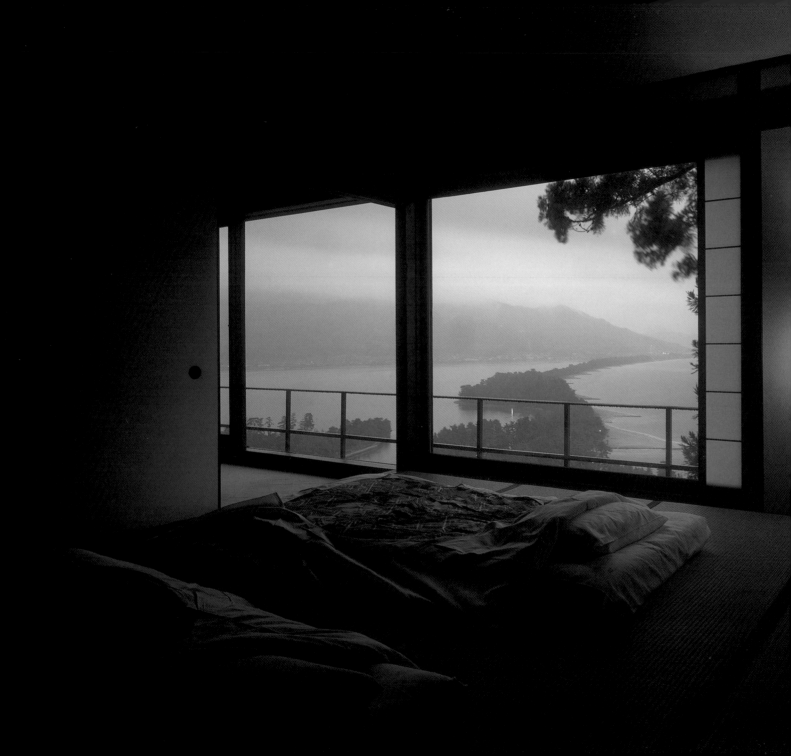

Ama-no-Hashidate, viewed from Suite 1-B

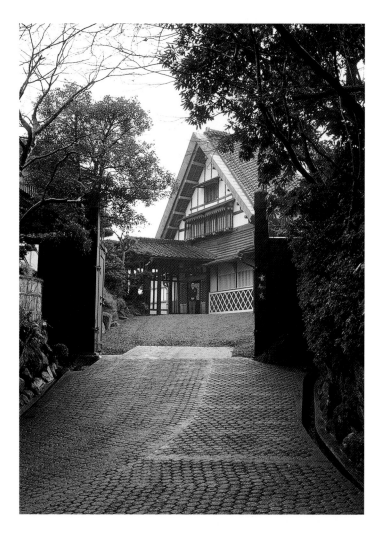

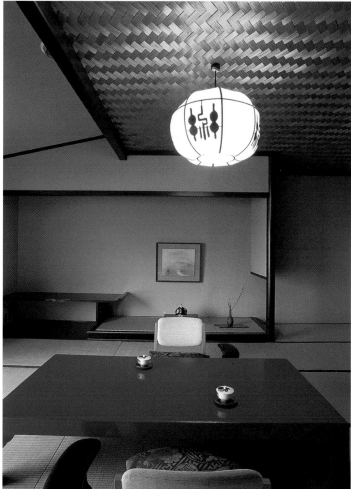

48

(L) Genmyoan: Entrance
(R) Genmyoan: 1-B Suite

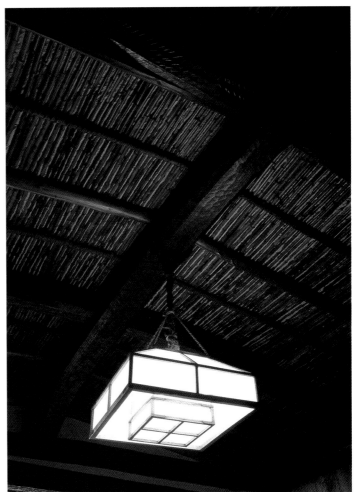

49

(L) Genmyoan: Annex Senshintei
(R) Genmyoan: Lobby ceiling

Karatsu
Yoyokaku

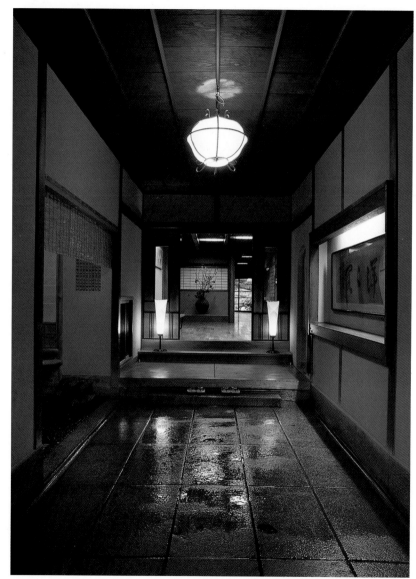

Entranceway after being ritually doused with water

Cottage facing the garden

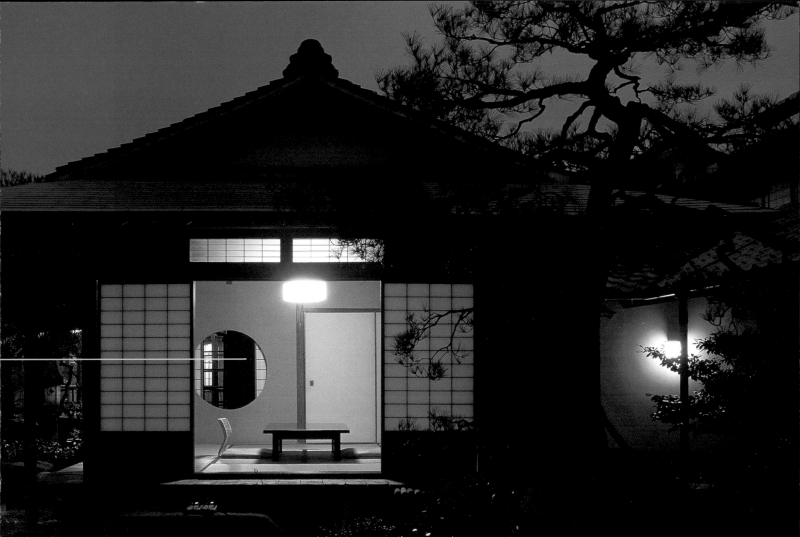

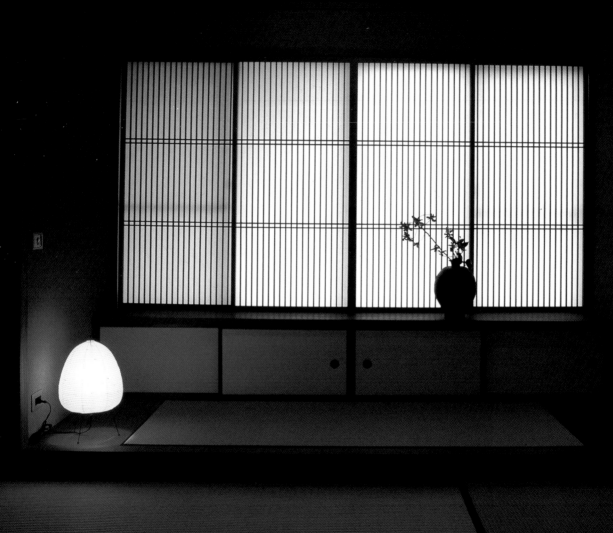

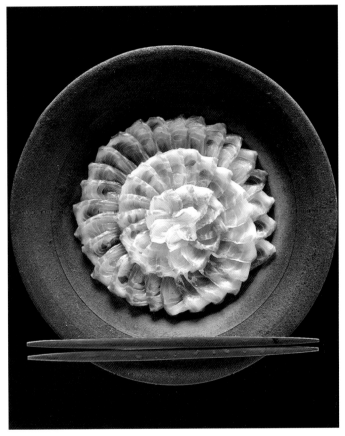

Yoyokaku: Sea bass sashimi on a piece of
Takashi Nakazato's Nanbanyaki pottery

Yoyokaku: Ukidake Suite

Lake Chimikeppu shining like a mirror in the morning

Lake Chimikeppu in the morning mist

Chimikeppu Hotel

Lake Chimikeppu at sunset

Chimikeppu Hotel
(UL) Entrance at evening
(UR) Lake Chimikeppu trout
(BL) American-made quilted bed covers
(BR) Light shining into a bedroom at dusk

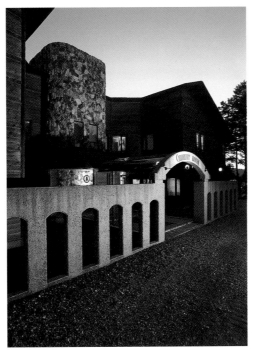
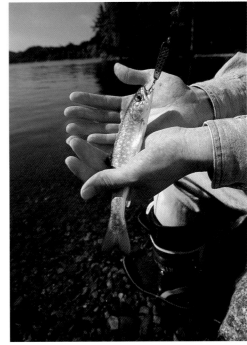

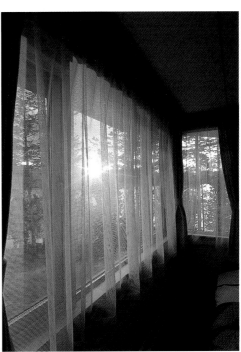

Yakushima: A paulownia leaf fallen on moss

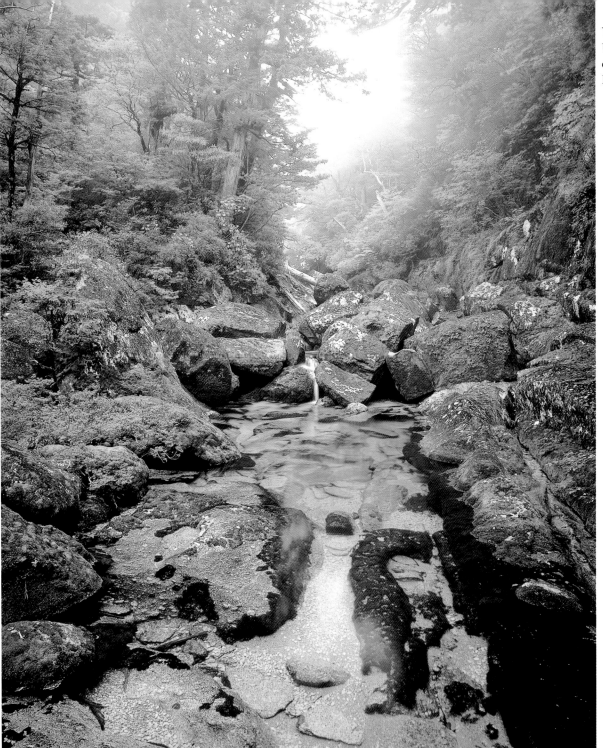

Yakushima:
Upper section
of the Yodo
River

59

Kagoshima
Yakushima Iwasaki Hotel

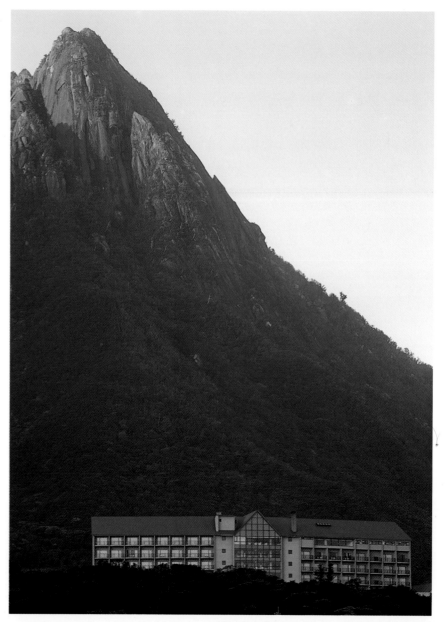

Mt. Mocchomu rising up behind the hotel

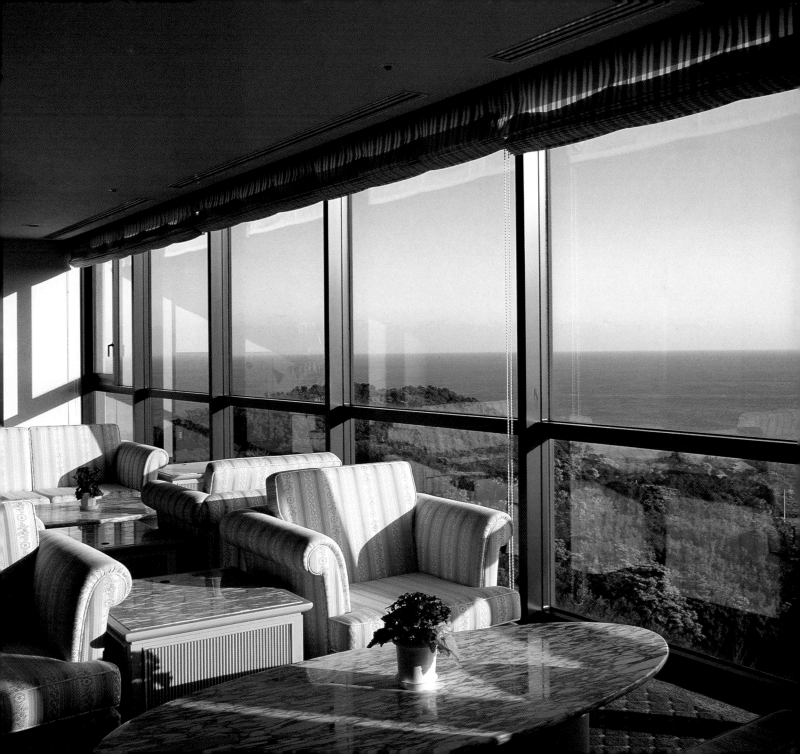

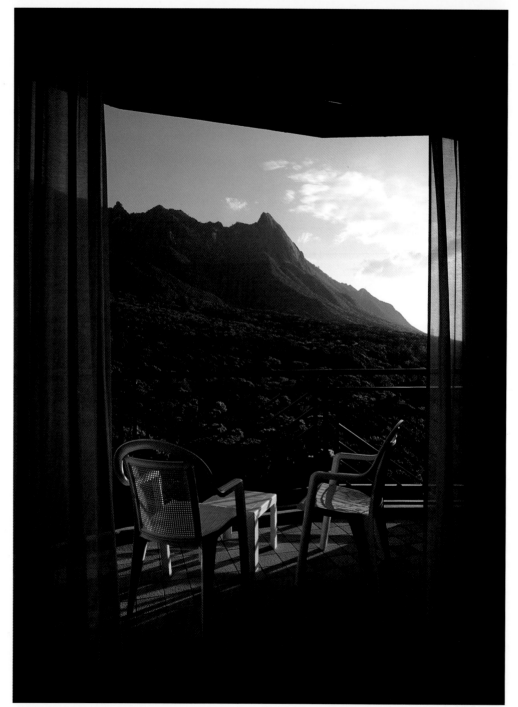

62

Yakushima Iwasaki Hotel: View from Room 431

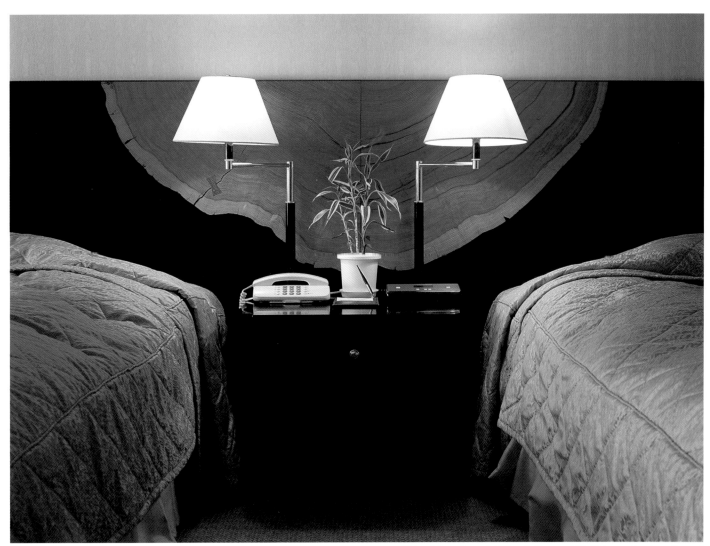

63

Yakushima Iwasaki Hotel: Room 402, Yaku cedar headboard

Okinawa
Hotel Nikko Aribira

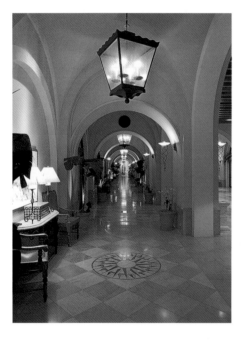

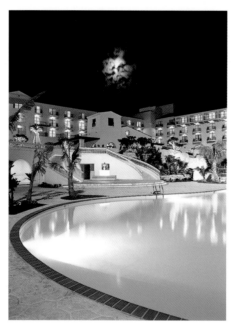

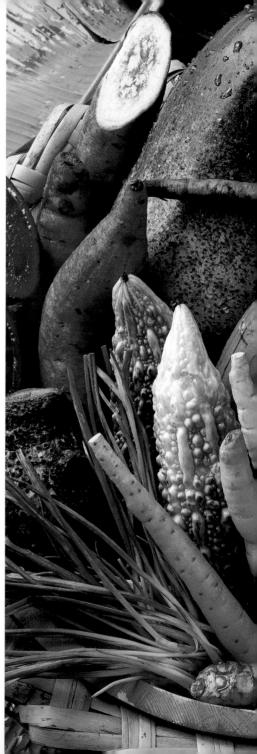

(64L) Caribbean-style interior
(64R) Poolside by the light of a hidden moon
(65L) Restaurant Sawa: local produce
(65R) Restaurant Sawa: local fish

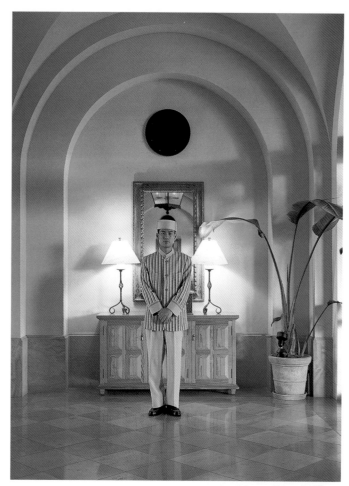

Hotel Nikko Aribira: Bellhop

Hotel Nikko Aribira: Deluxe Suite 1818

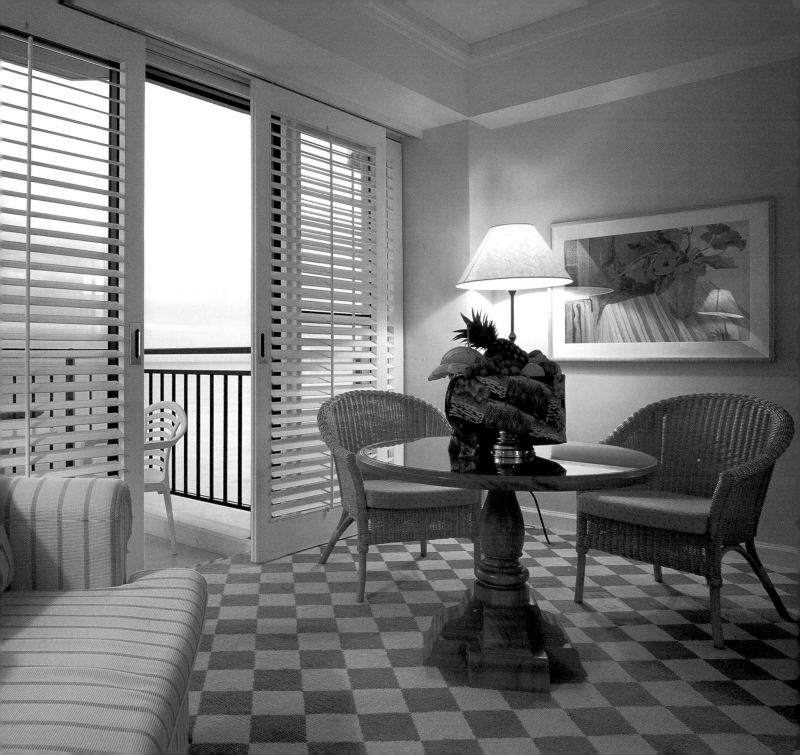

Shuzenji
Arai Ryokan

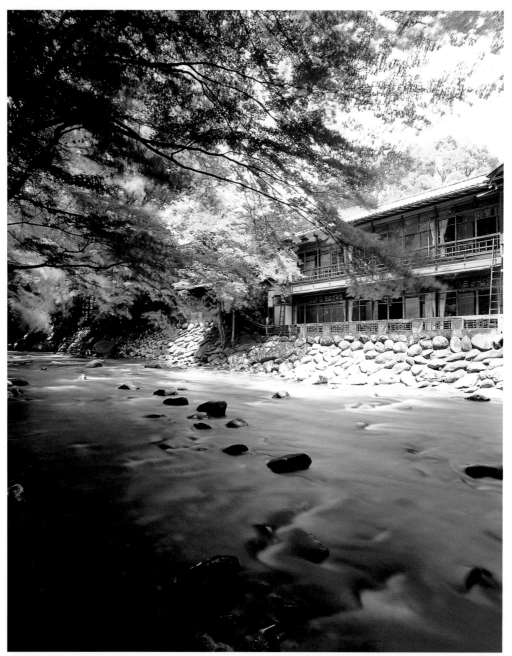

Guest rooms overlooking the Katsura River

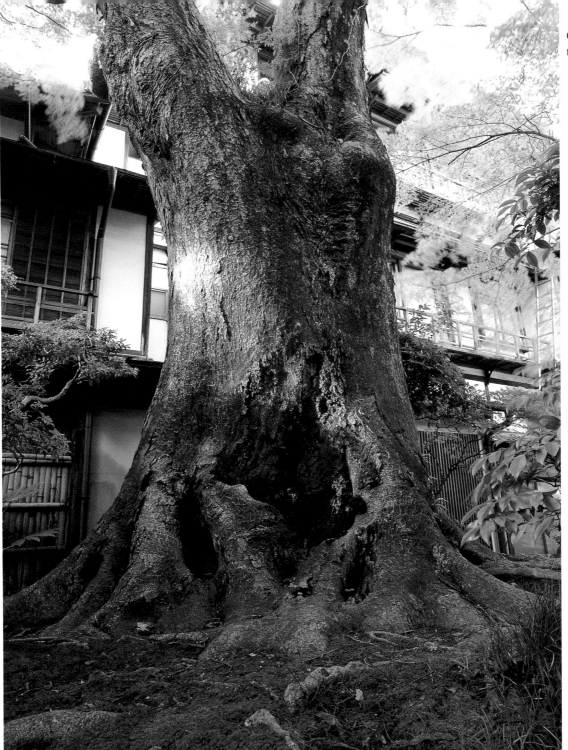

Giant zelkova tree in
the central garden

69

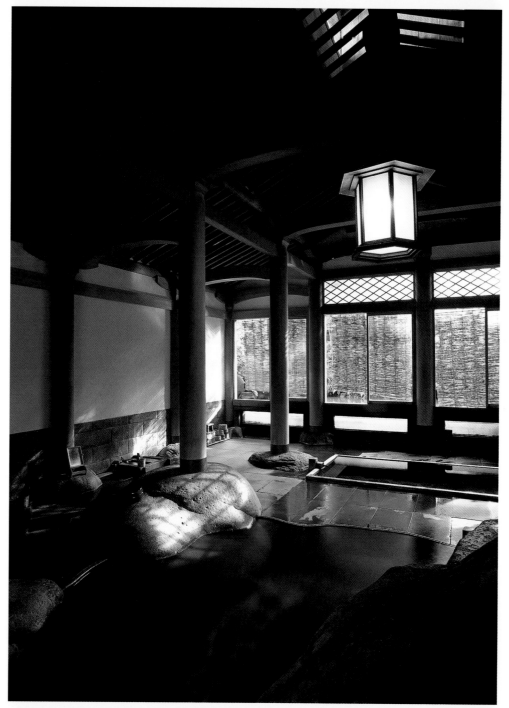

Arai Ryokan: Tempyo Daiyokudo

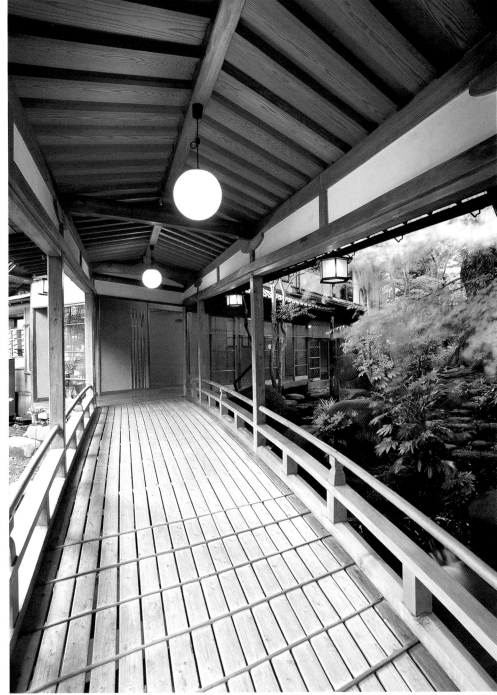

Arai Ryokan: Diverted stream flowing under corridor

Geta crafted from a wooden lid

Shigetsu: Kangetsu Suite

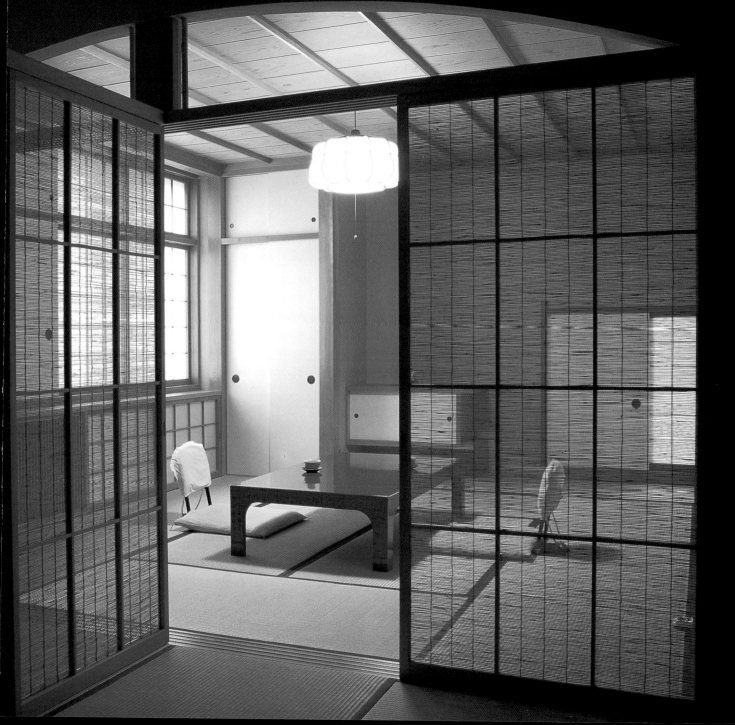

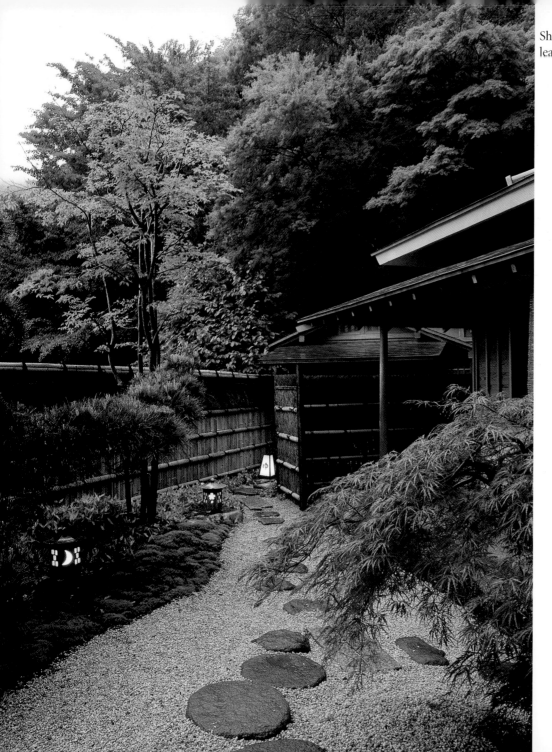

Shigetsu: Stepping stones through the garden leading to the hot springs

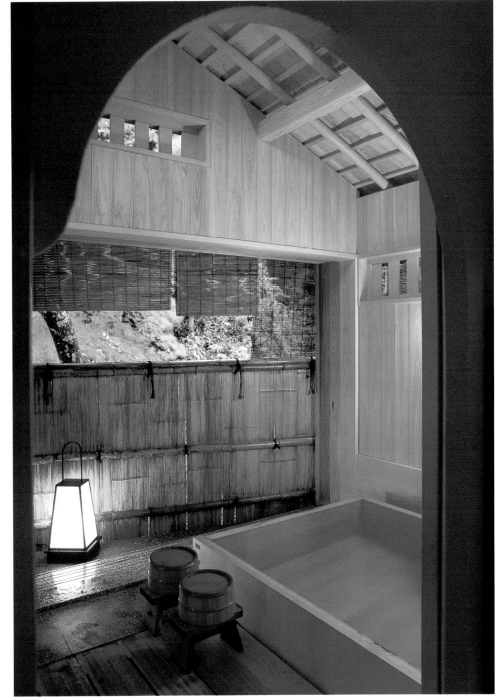

Shigetsu: Cypress bathing room

Shigetsu: Tea room in the Kangetsu Suite

Shigetsu

(UL) Shiroae in an E-Karatsu dish from the Momoyama Period

(UR) Ise shrimp in citron sauce in a Bizen pottery bowl

(BL) Eel and shiitake mushrooms in a Jihē I bowl

(BR) Breem sashimi in an Edo Era bowl

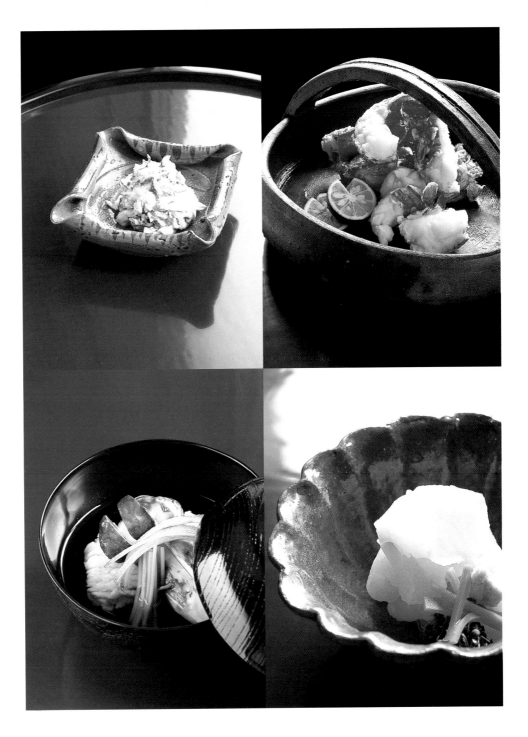

77

Park Hyatt Tokyo

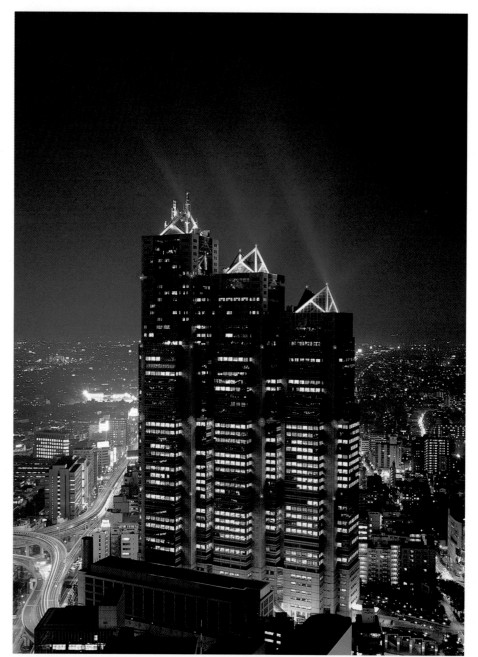

The Park Hyatt against the Tokyo skyline at night Diplomat Suite on the fiftieth floor

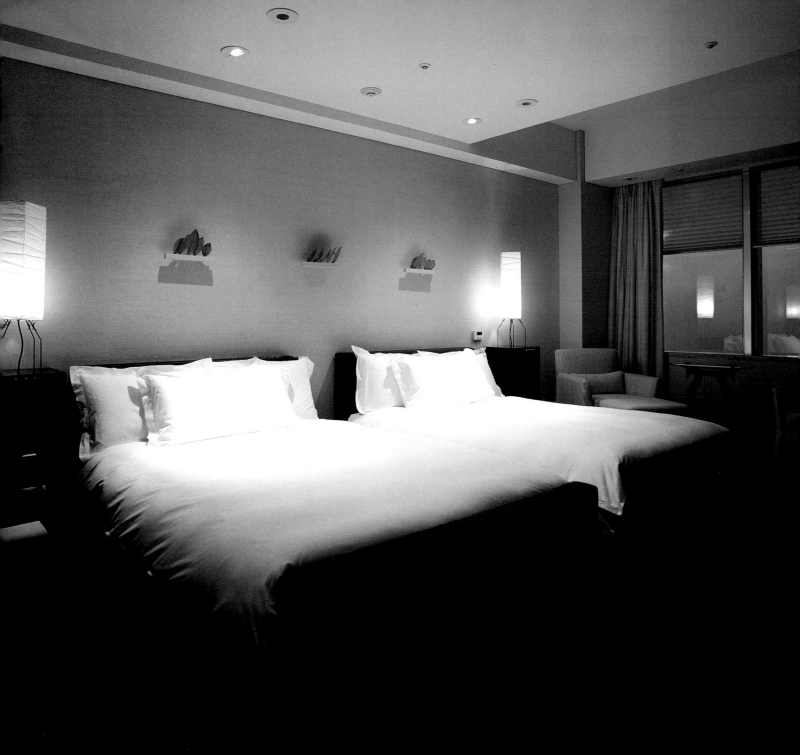

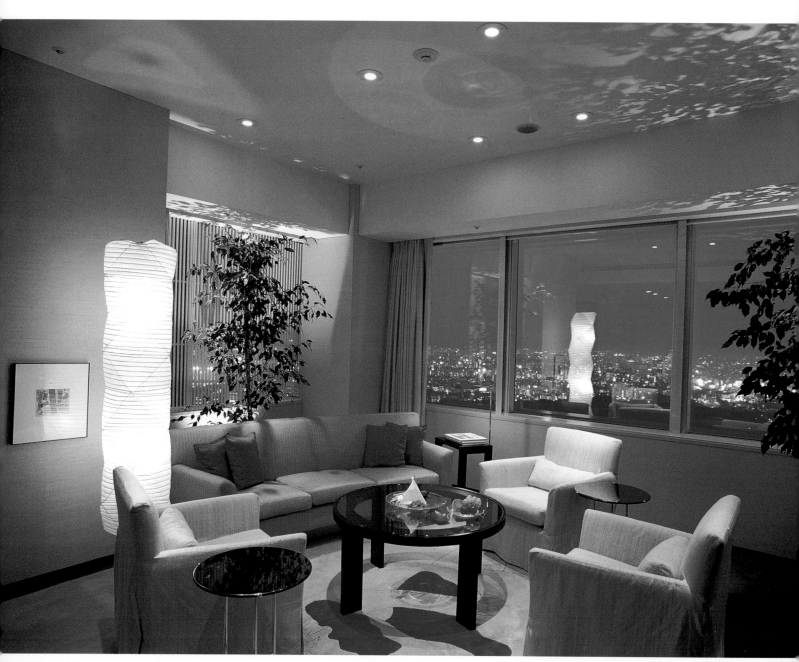

Park Hyatt Tokyo: Diplomat Suite on the fiftieth floor

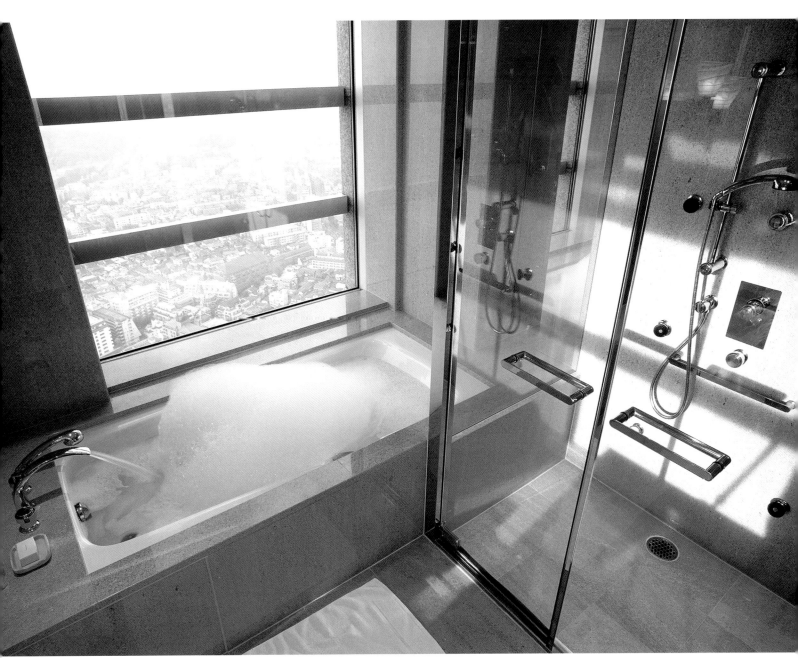

Park Hyatt Tokyo: Diplomat Suite on the fiftieth floor

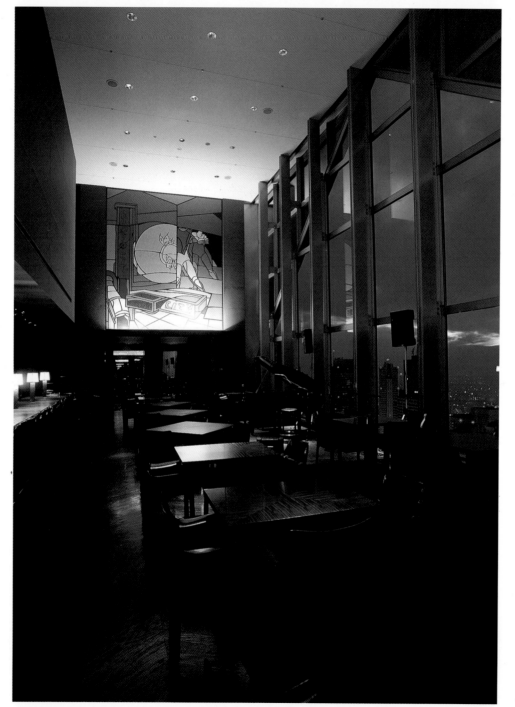

Park Hyatt Tokyo: New York Bar on the fifty-second floor

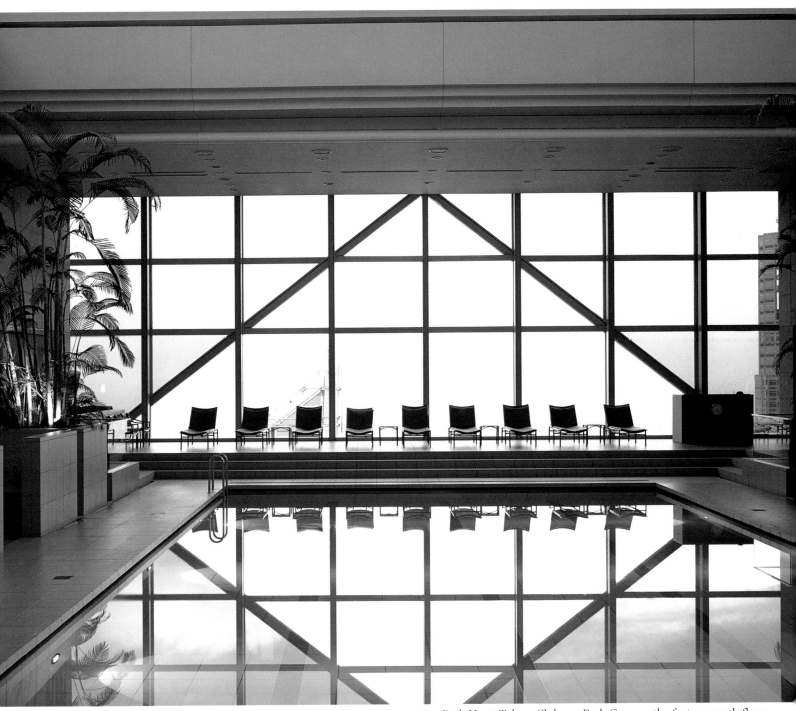

Park Hyatt Tokyo: Club-on-Park Gym on the forty-seventh floor

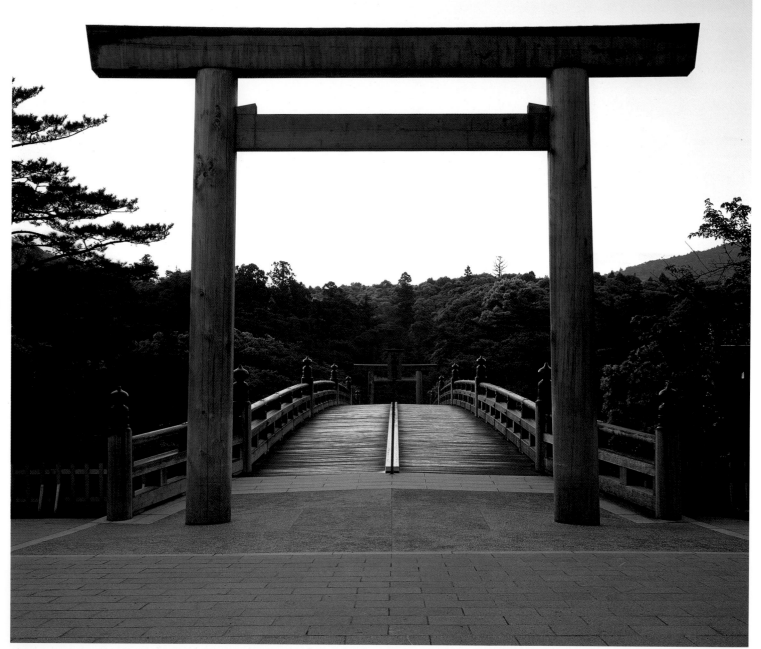

Ise Shrine: Torii gate at the entrance to the shrine

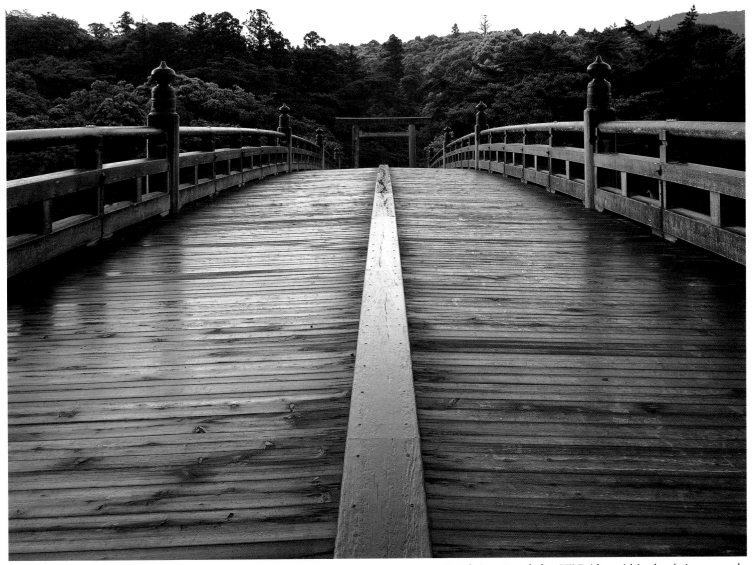

Ise Shrine: Dew-laden Uji Bridge within the shrine grounds

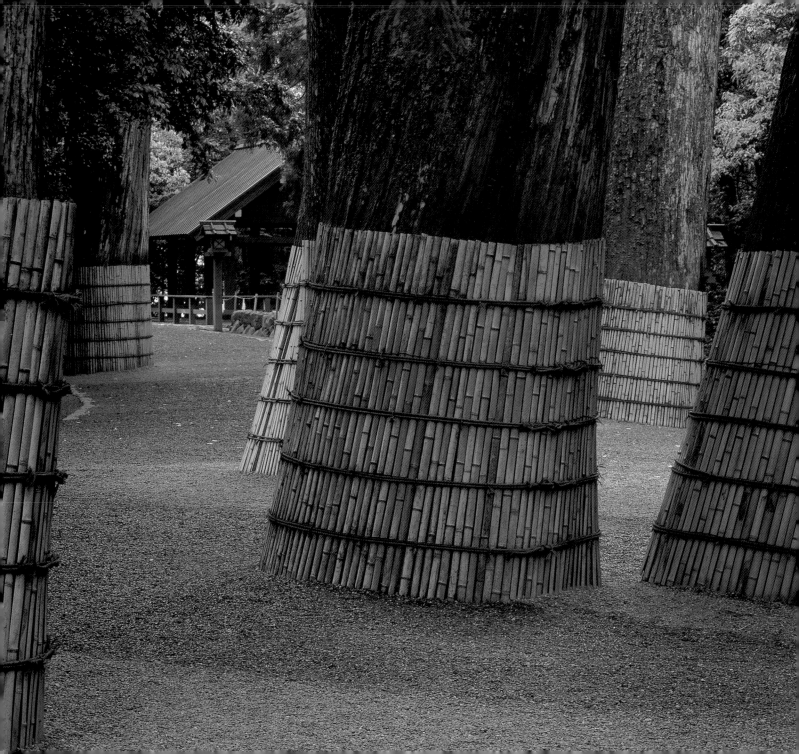

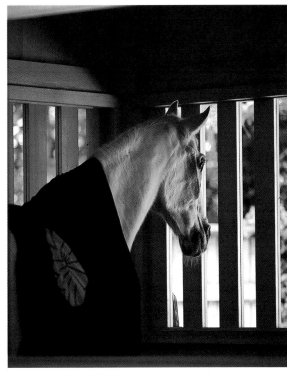

Ise Shrine: Temple horse at the Outer Shrine

Ise Shrine: Giant Japanese cedars on the shrine's path

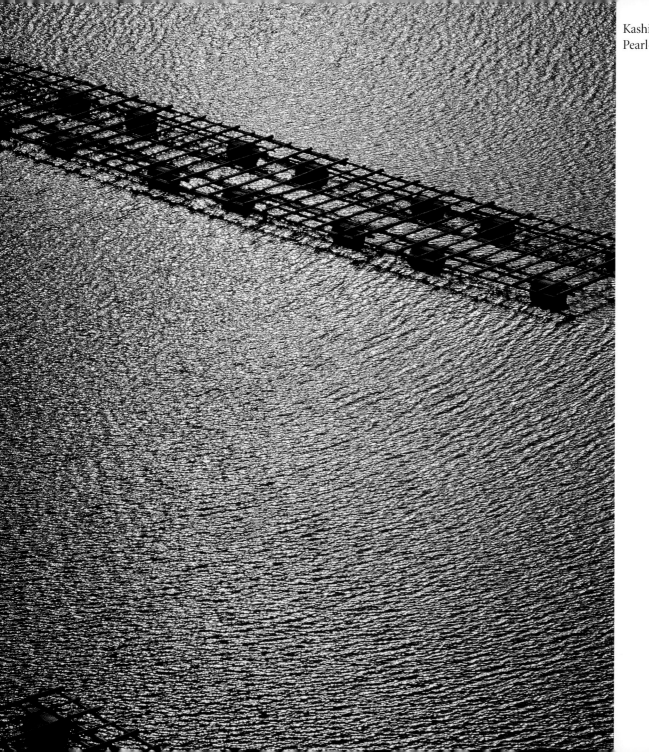

Kashikojima:
Pearl-bearing oyster farm

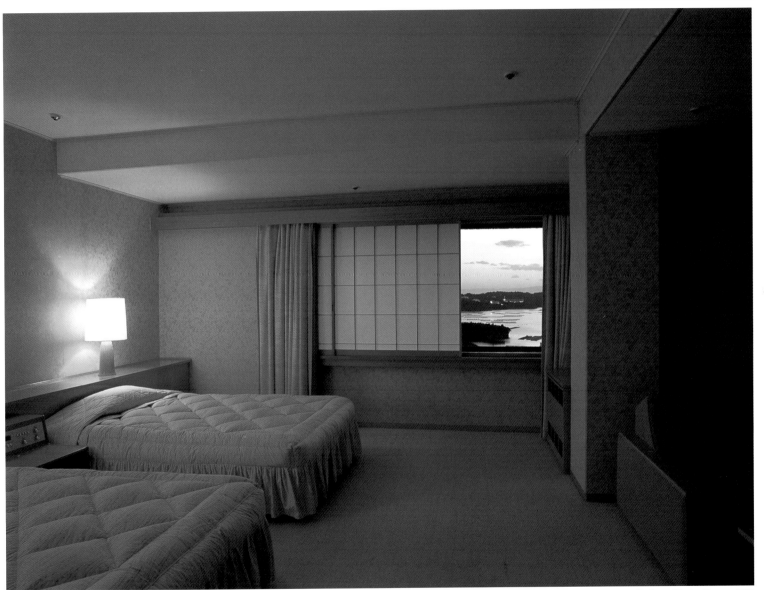

Deluxe Twin Room 502

Shima Kanko Hotel: Main dining room, La Mer plate

Shima Kanko Hotel
(UL) Main dining room being prepared for dinner
(UR) Ise shrimp dish entitled "Journeying About
the Sea for a Day" (shrimp in American
truffle sauce)
(BL) Abalone dish entitled "Listening to the Call
of the Ocean" (abalone steak)
(BR) Evening sun streaming into dining room

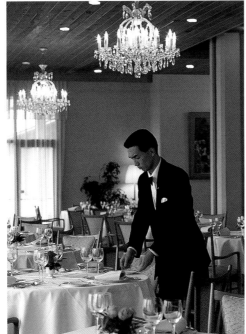

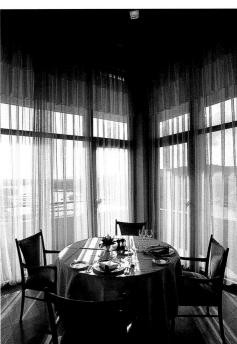

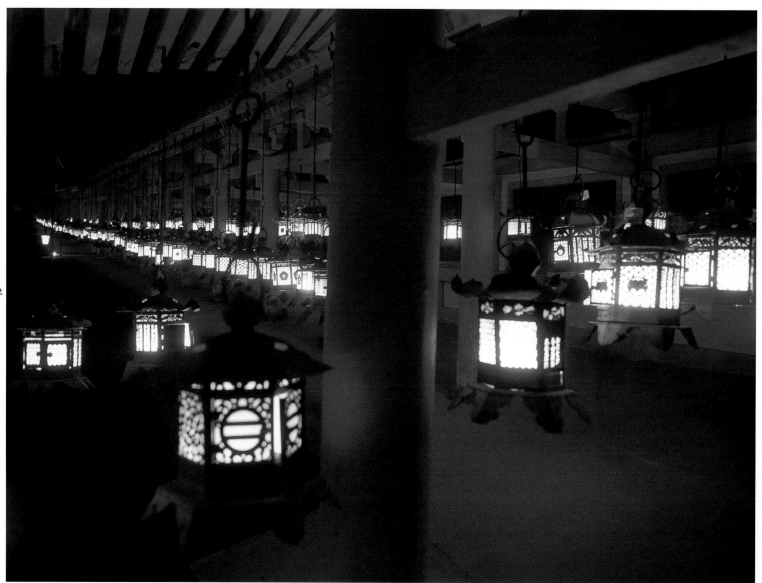

(92) Nara Kasuga Shrine: Festival of Ten Thousand Lanterns (August 14 and 15)
(93) Nara Todaiji: Banto Kuyoue (August 15)

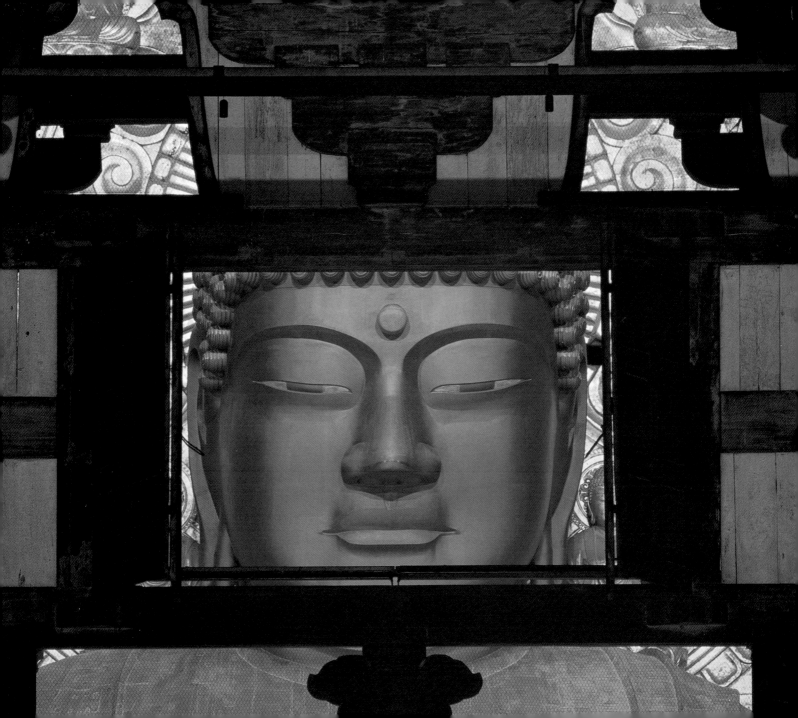

Edosan

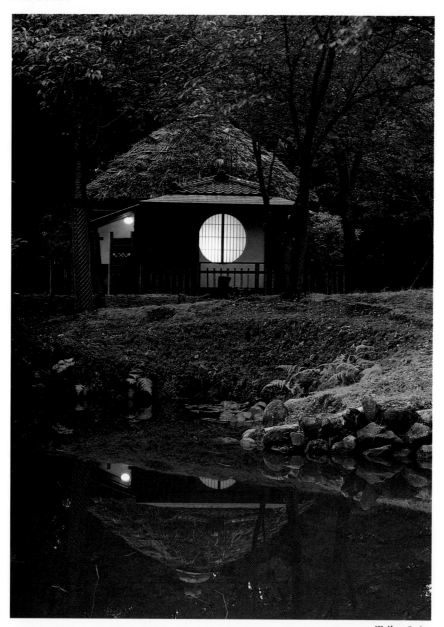

Taiko Suite

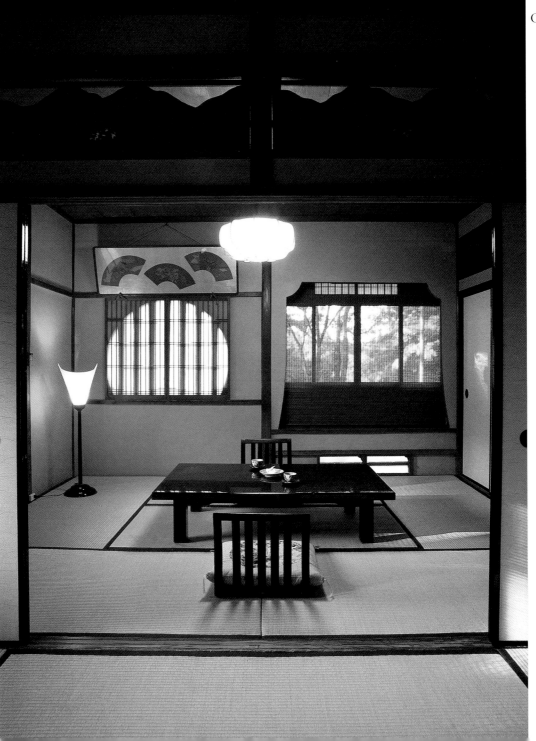

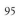

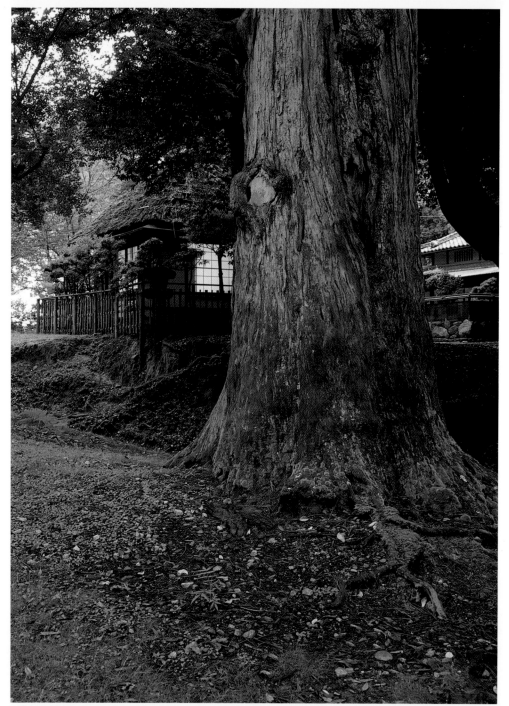

Edosan: Giant tree in Nara Park and Taiko Suite

Edosan

(UL) Stone lantern
(UR) Rabbit lintel carving in Central Suite
(BL) Circular window in Eight Directions Suite
(BR) Fish carving at entrance

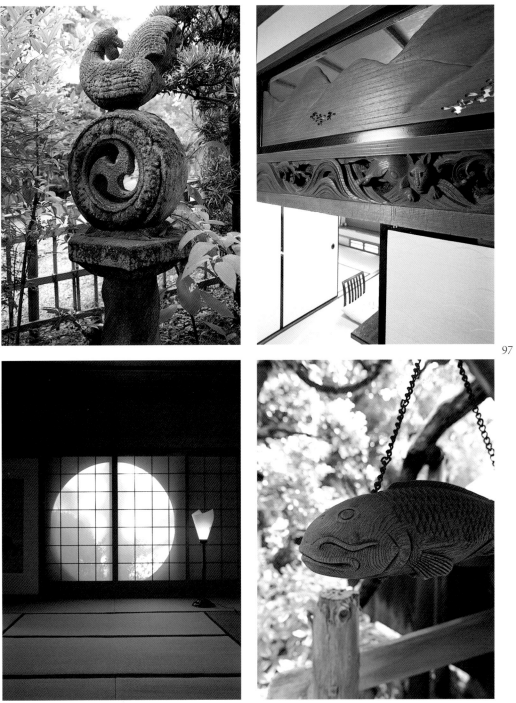

Tawaraya Ryokan

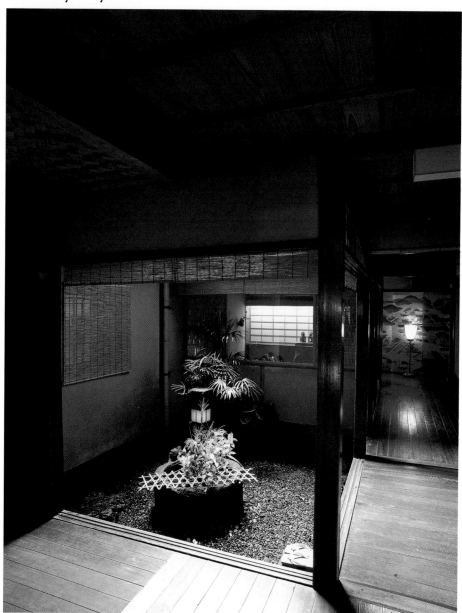

Indoor garden

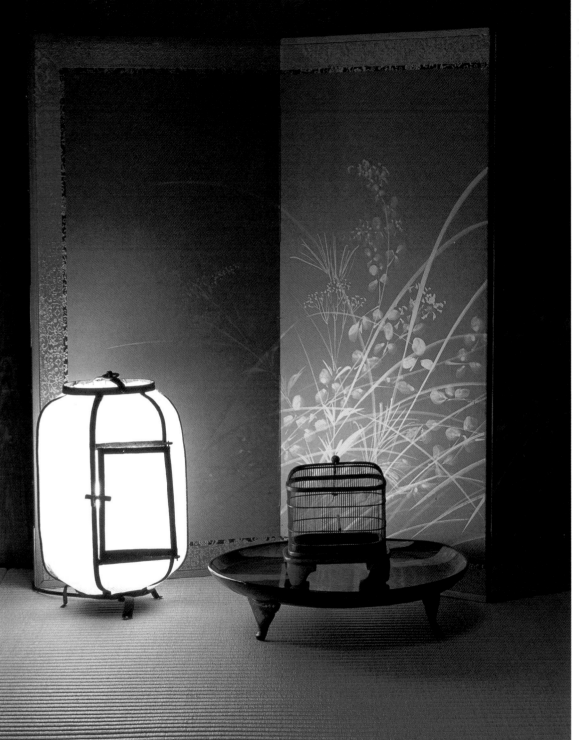

Entrance display
commemorating
the beginning of
autumn

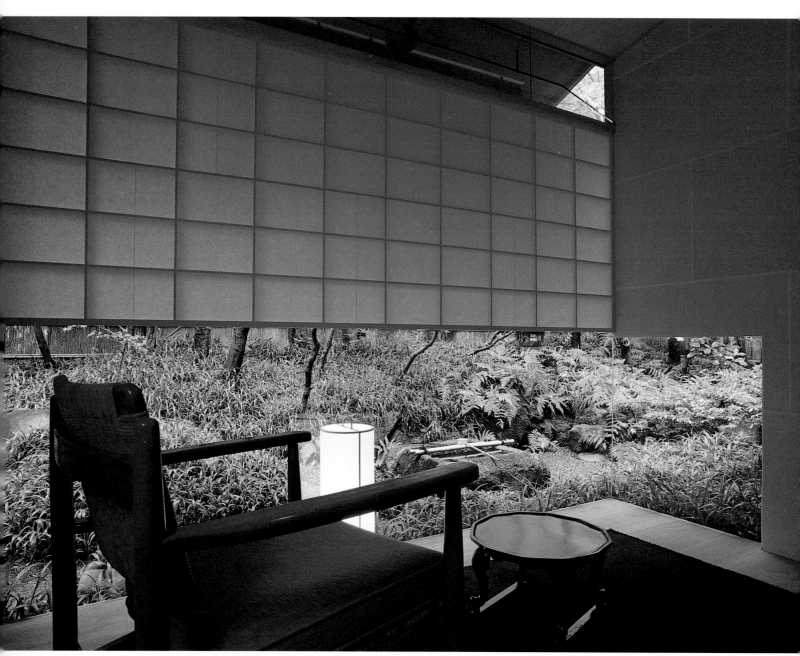

Tawaraya Ryokan: Firefly Suite

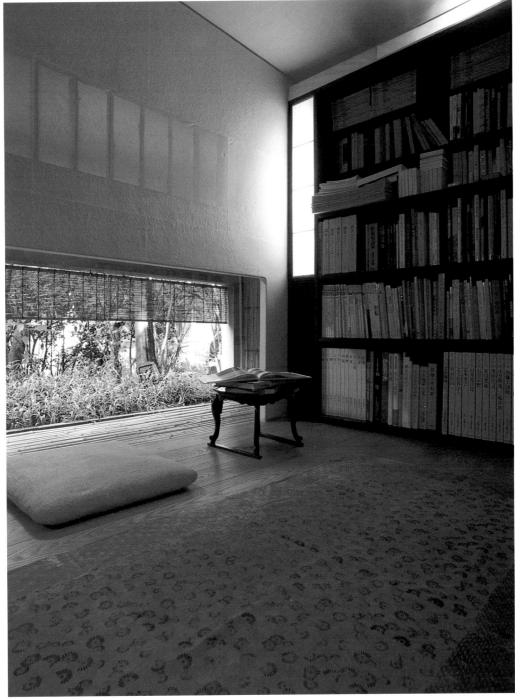

Tawaraya Ryokan: Library

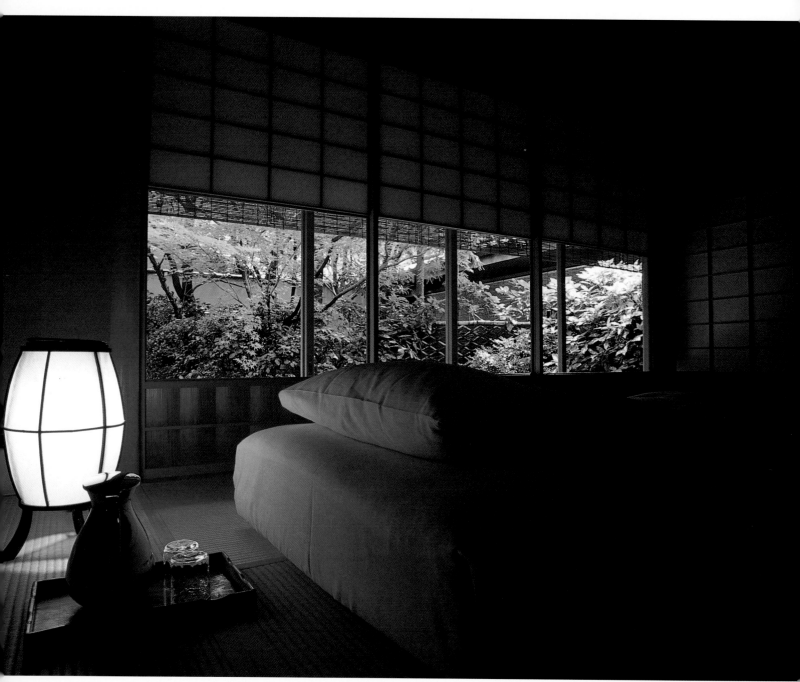

Tawaraya Ryokan: Shorai Suite

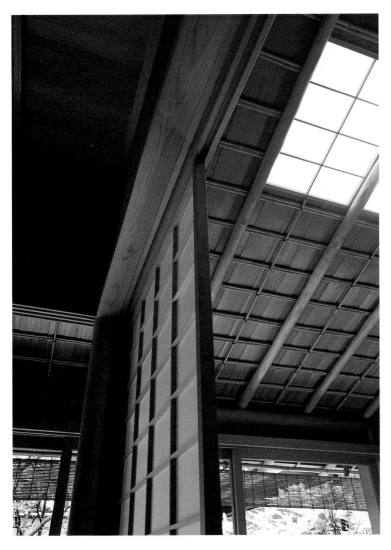
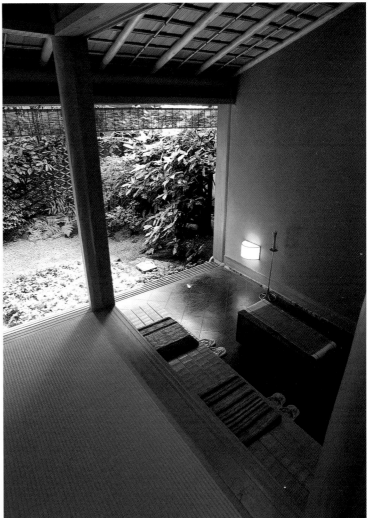

(L) Tawaraya Ryokan: Skylight in Shorai Suite
(R) Tawaraya Ryokan: Detail of doorframe woodwork in Shorai Suite

104

Tawaraya Ryokan: Fuji Suite viewed from the garden

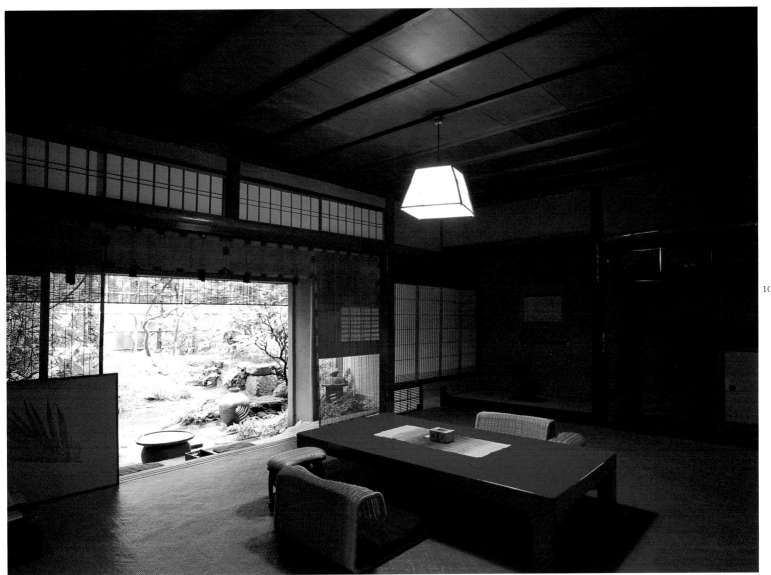

Tawaraya Ryokan: Fuji Suite

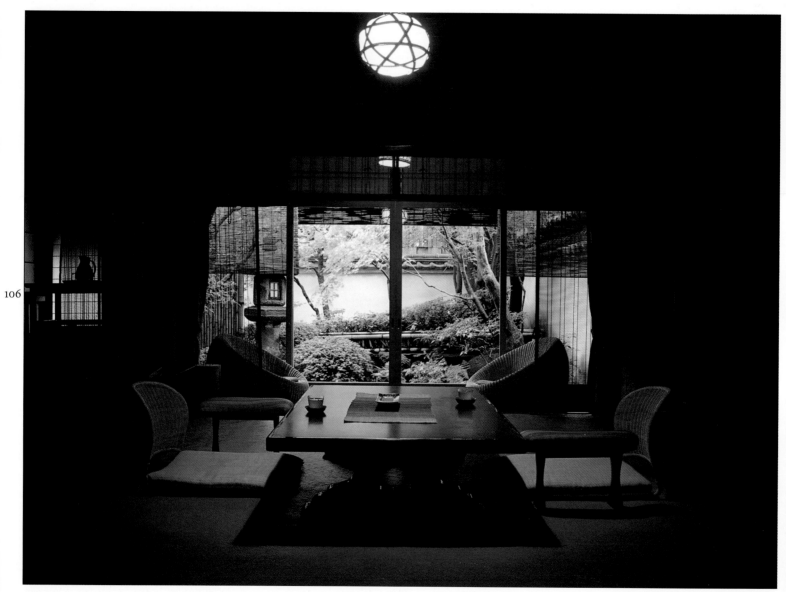

Tawaraya Ryokan: Spring Suite

Tawaraya Ryokan
(UL) Entrance
(UR) Shorai Suite: Stepping stones in the garden
(BL) Spring Suite's bath
(BR) A bulbul visiting the garden

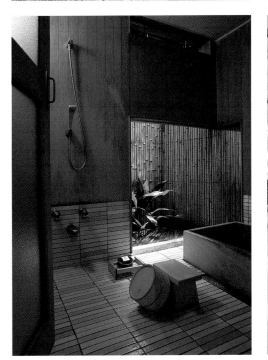

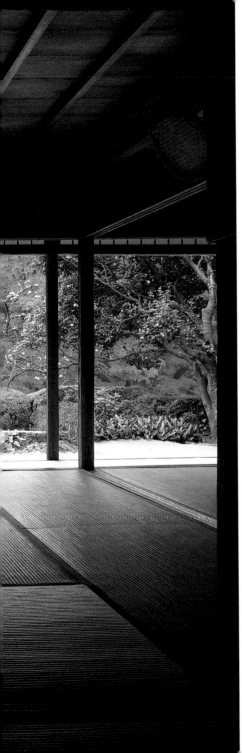

Kyoto Shisendo

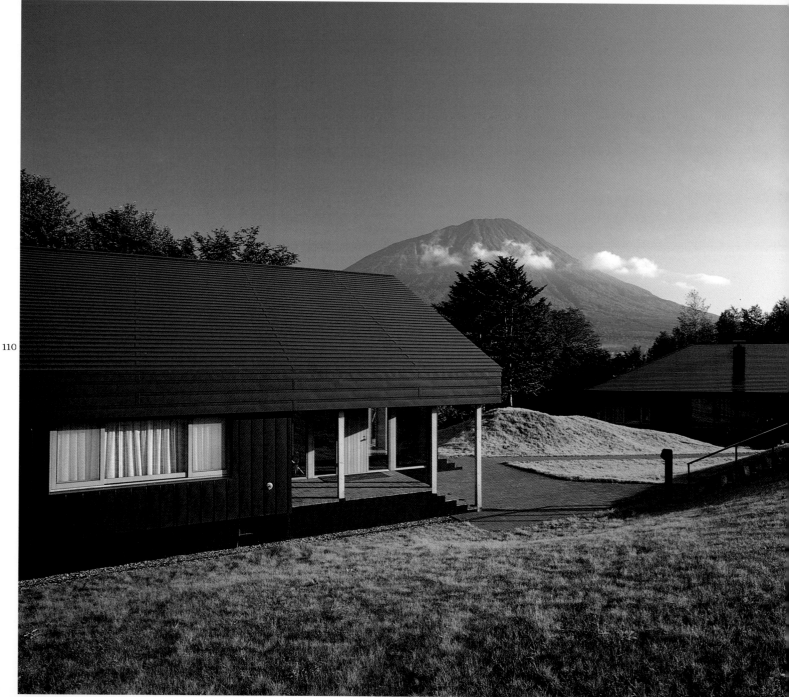

110

Mt. Yotei in the early morning. Guest cottage on left; dining room on right.

Maccarina

Wreath at restaurant entrance

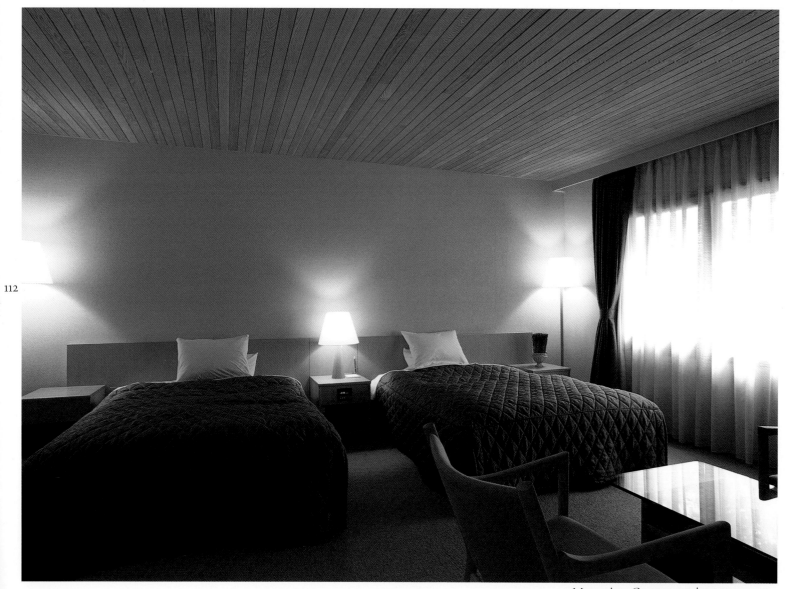

112

Maccarina: Guest room in cottage
Maccarina: Fireplace in restaurant lobby

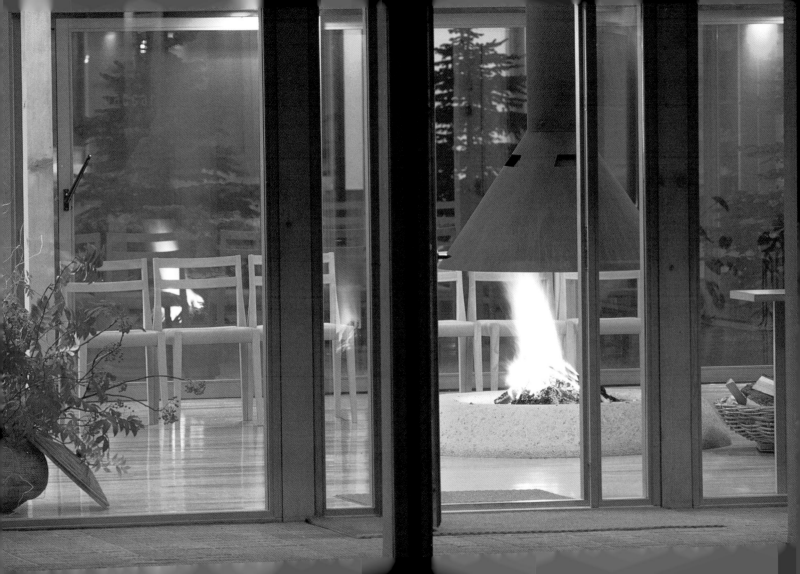

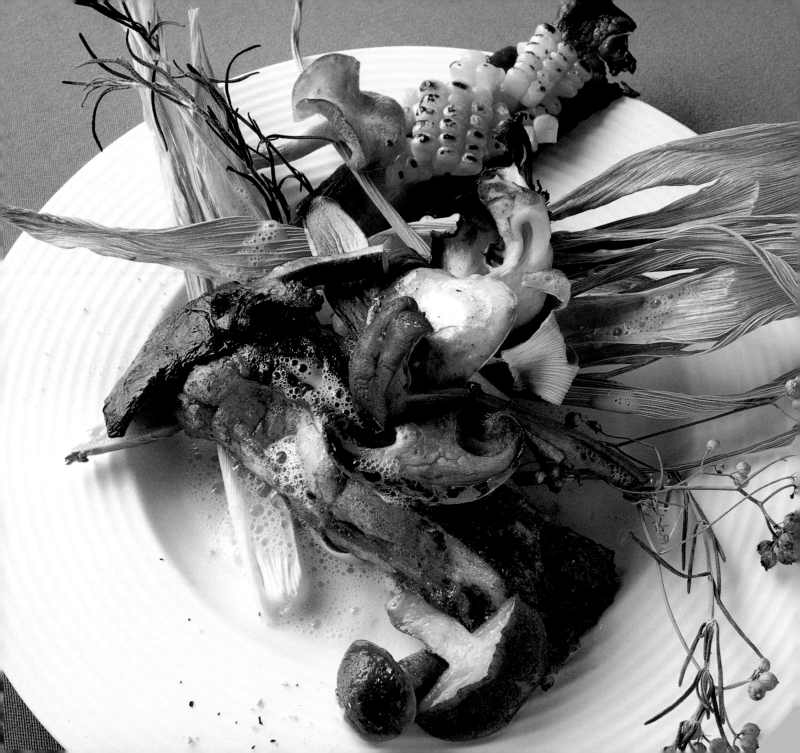

Maccarina: Flounder meunière and the bounty of the fields

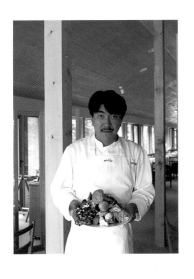 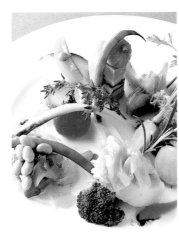 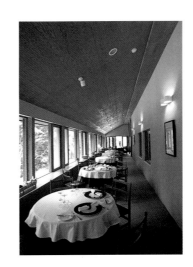 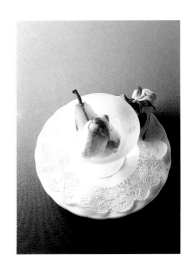

Maccarina
(L) Chef Shinichi Sugaya
(LC) Assorted vegetable hors d'oeuvres
(RC) Dining room
(R) Pear compote and milk sherbet

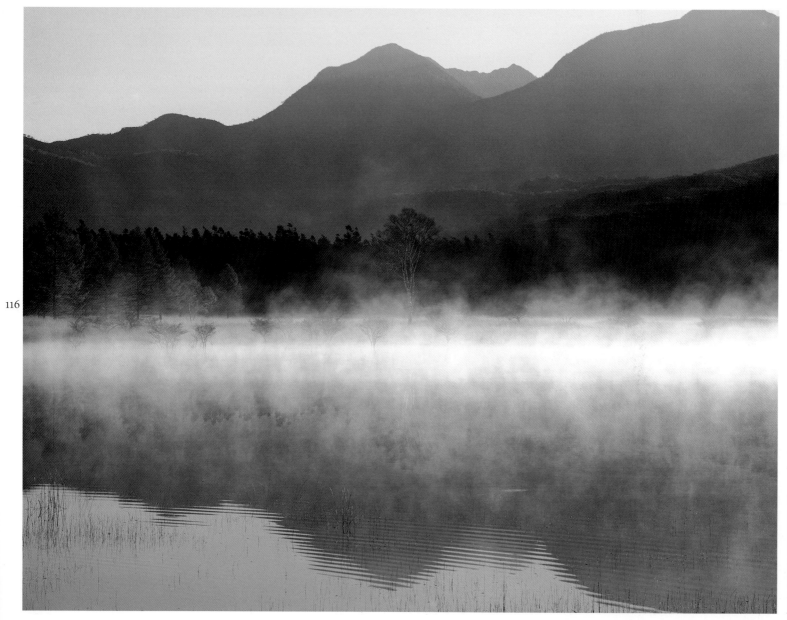

116

Nikko: Odashirogawara's white birches in the morning mist

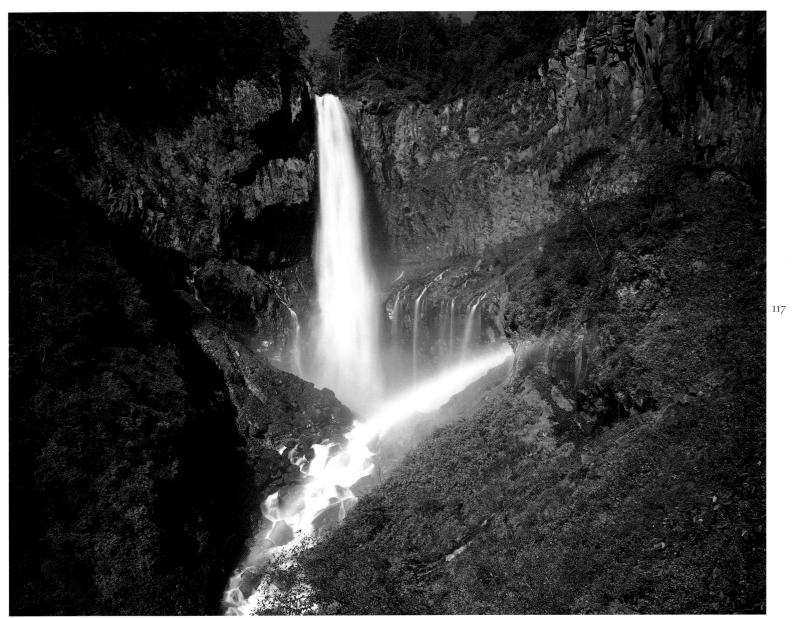

Nikko: Rainbow at Kegon Falls

Nikko: Kirifuri Falls

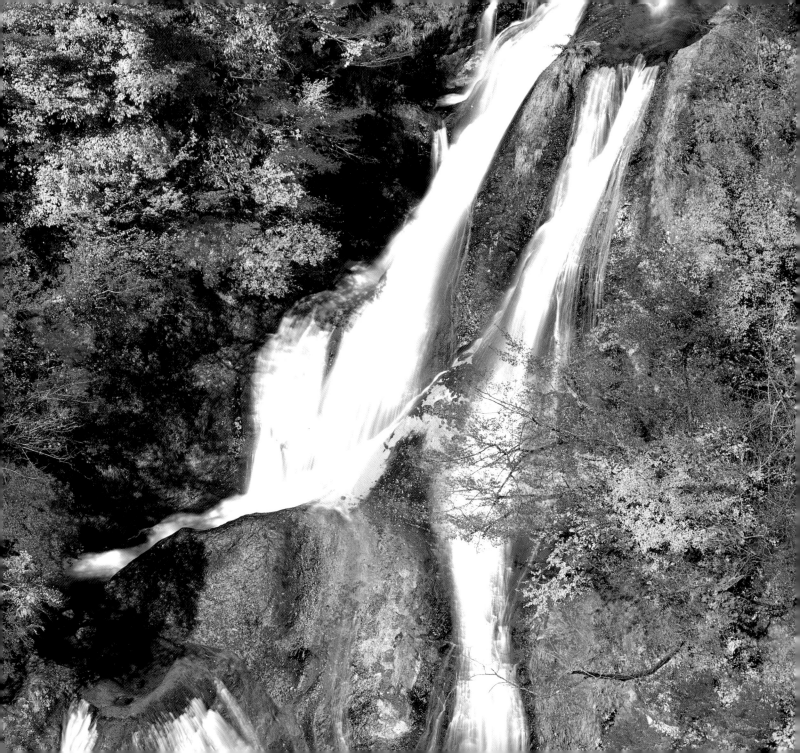

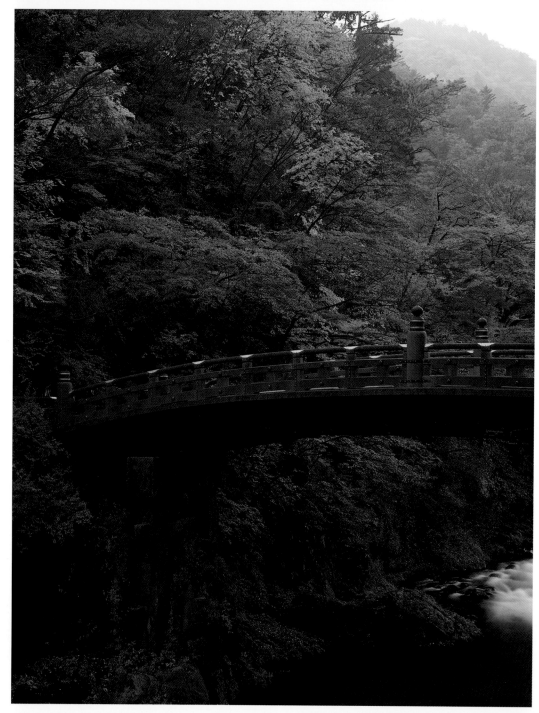

Nikko: Shinkyo Bridge, above the Daiya River

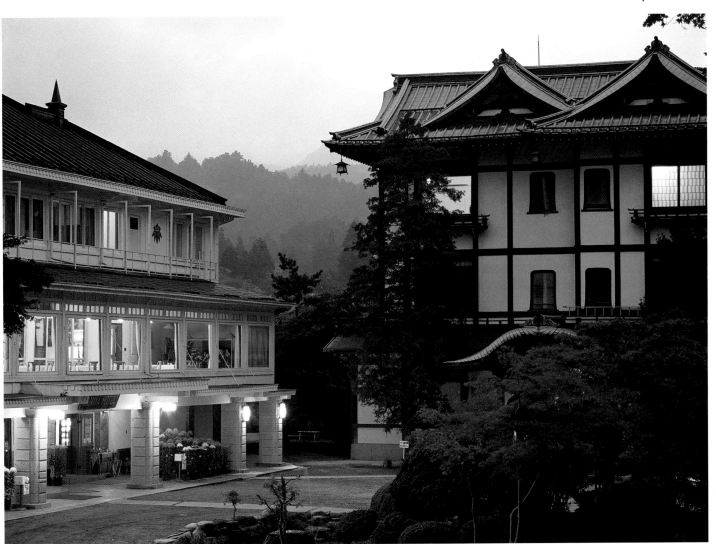

A view of Mt. Nantai: Main building on left, annex on right.

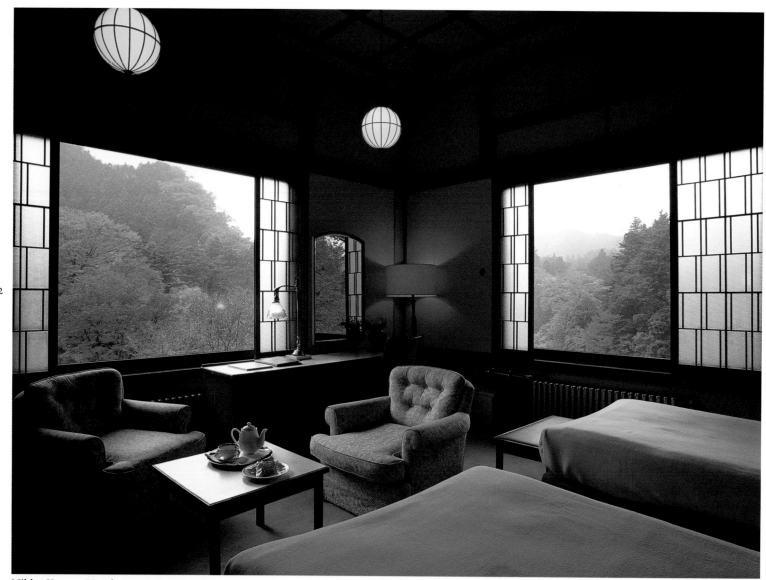

122

Nikko Kanaya Hotel: Annex Room 122

Nikko Kanaya Hotel
(UL) Front desk
(UR) Dining room
(BL) The famous rainbow-trout meunière
(BR) The dining room, prepared for dinner

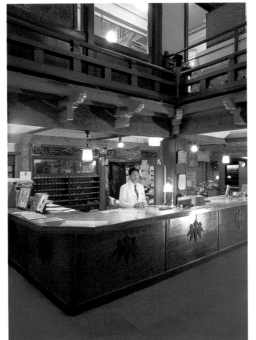

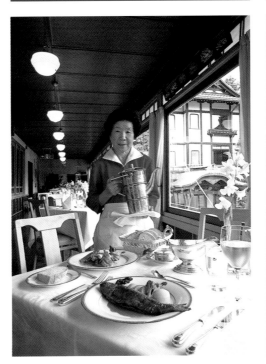
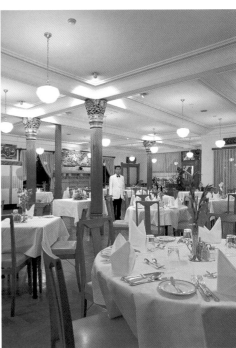

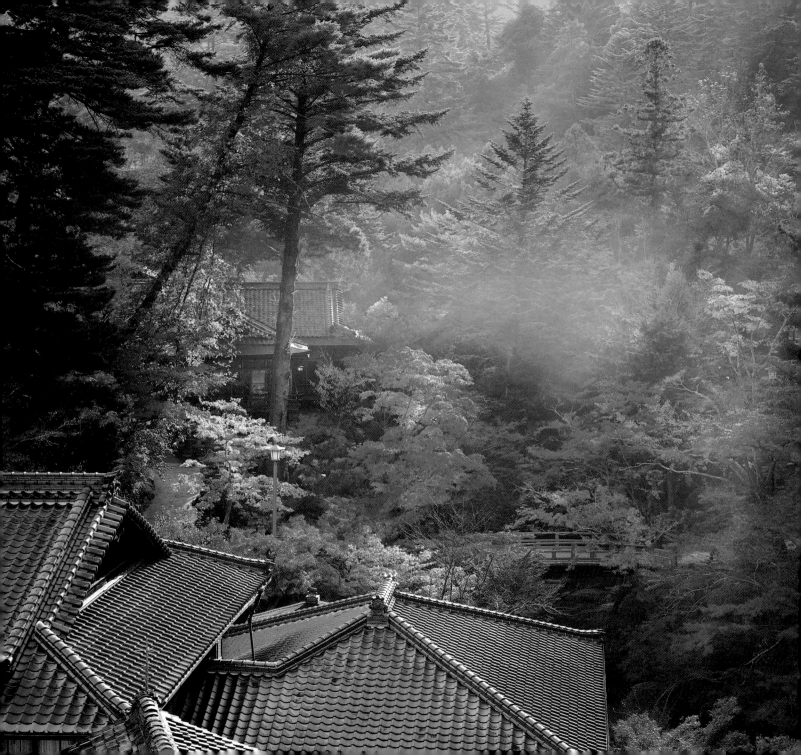

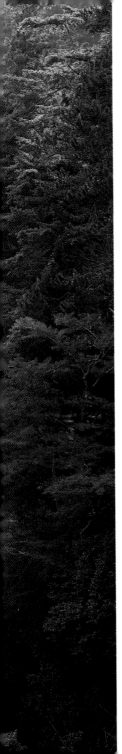

Miyajima
Iwaso

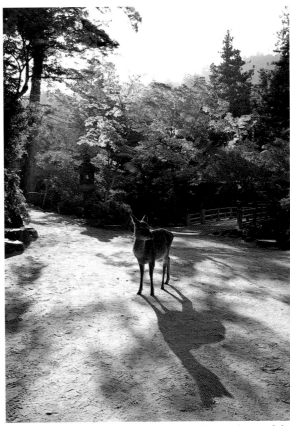

A deer in front of the
inn early one morning

The autumn leaves of Momiji Valley, viewed from a window in the New Annex

126

Iwaso: Brightly lit exterior at dusk

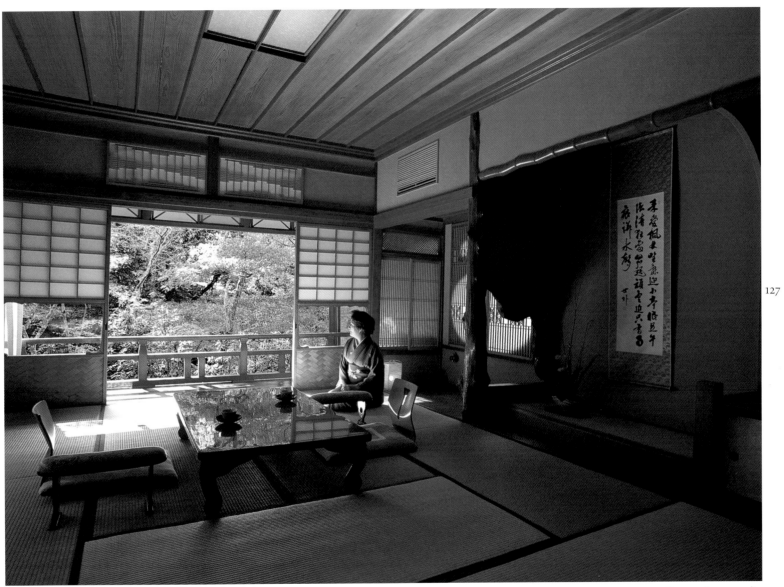

Iwaso: Annex suite

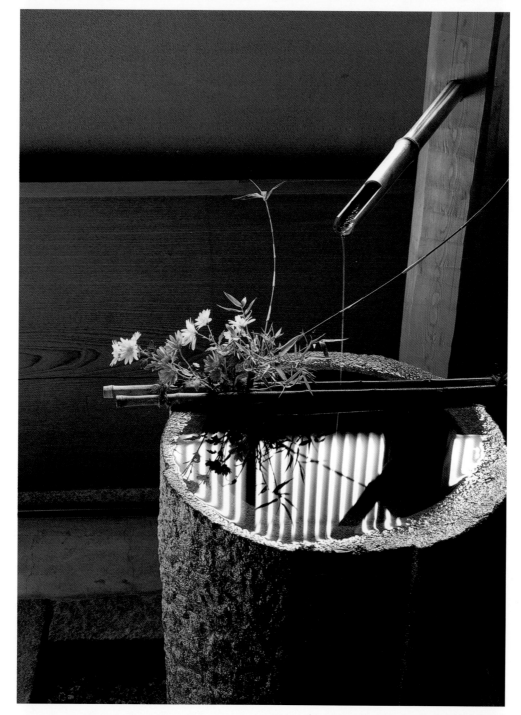

Iwaso: Stone fountain at entrance

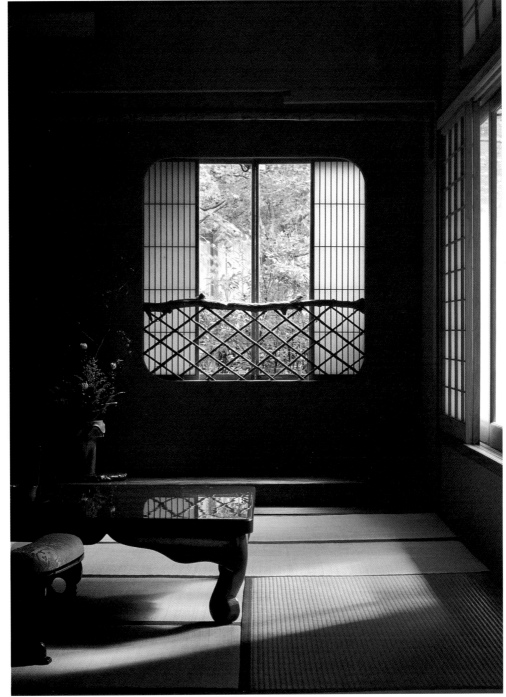

Iwaso: View from an annex window

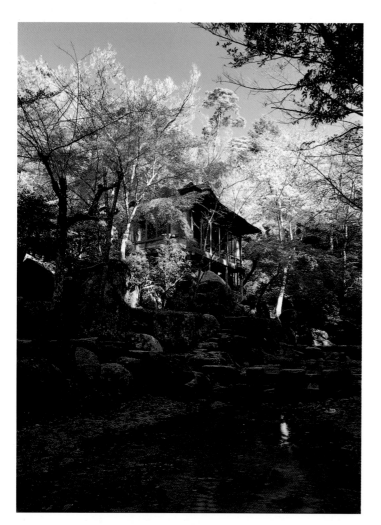

(L) Iwaso: Annex, viewed across the Momiji River
(R) Iwaso: View through an annex window

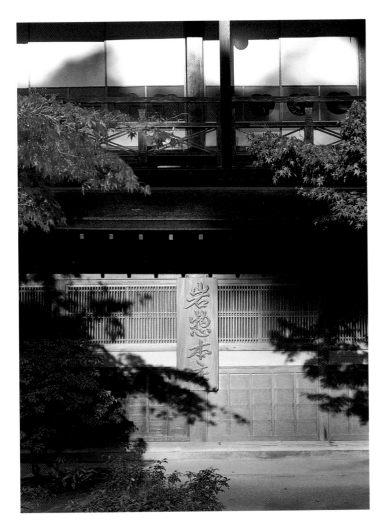

(L) Iwaso: Entrance to the main building
(R) Iwaso: Annex skylight

Wasure-no-Sato Gajoen

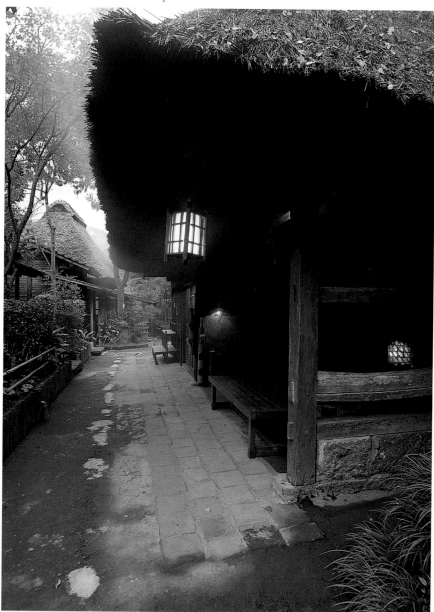

An old farmhouse transplanted

132

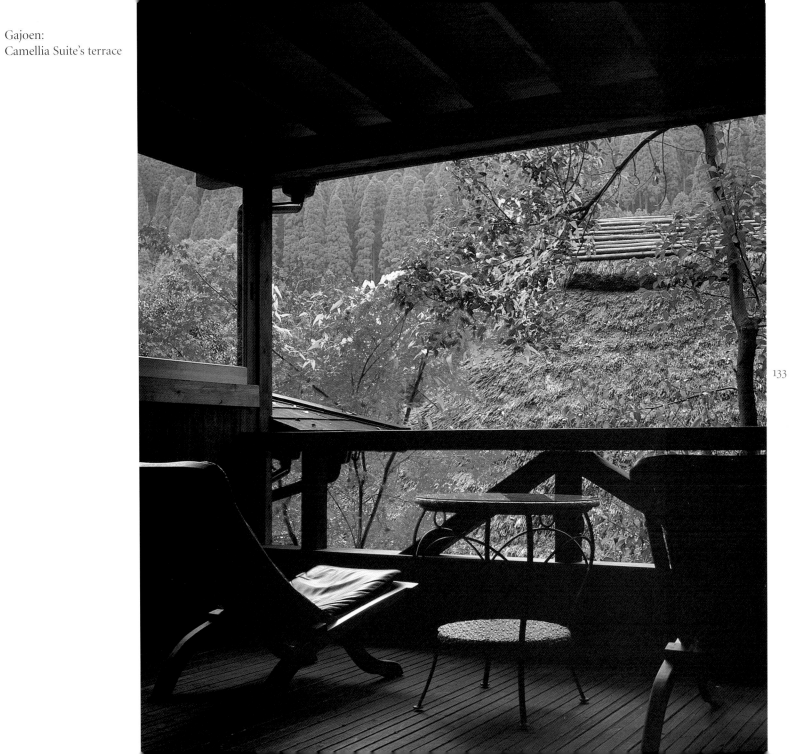

Gajoen:
Camellia Suite's terrace

133

Gajoen: Takeru Bath, carved from a single stone

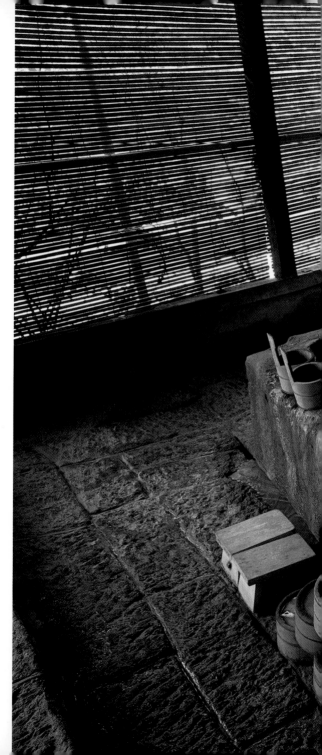

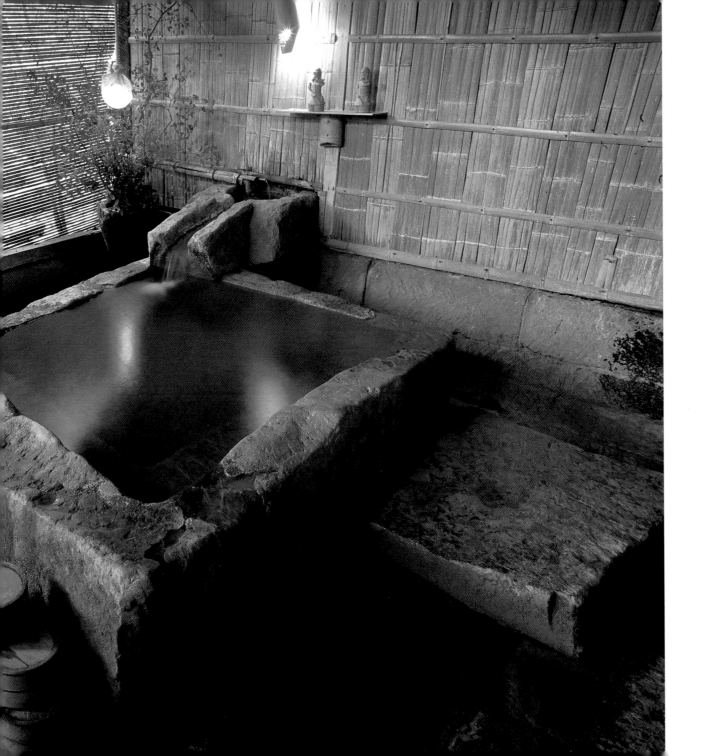

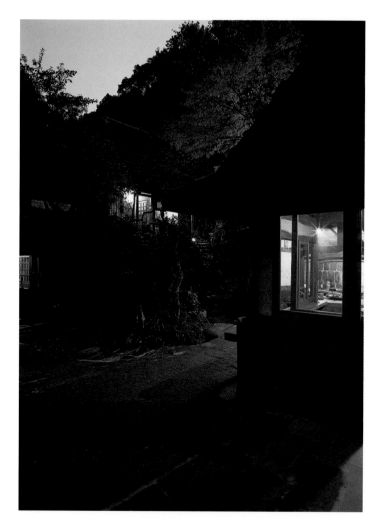

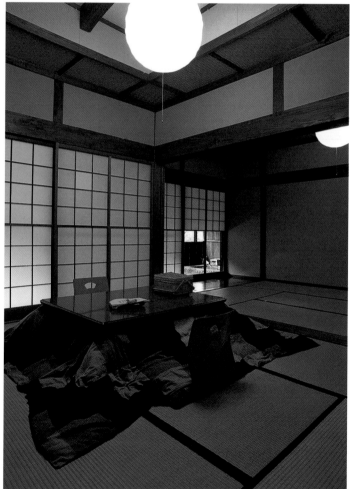

(L) Gajoen: Dinnertime approaches
(R) Second floor of the Camellia Suite

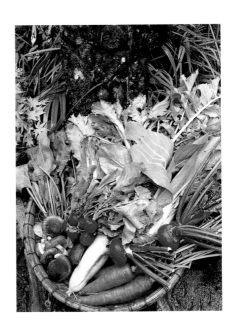
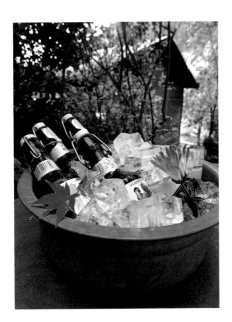
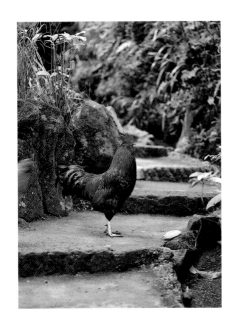

Gajoen
(L) Local produce
(C) After-bath beer
(R) One of the inn's roosters

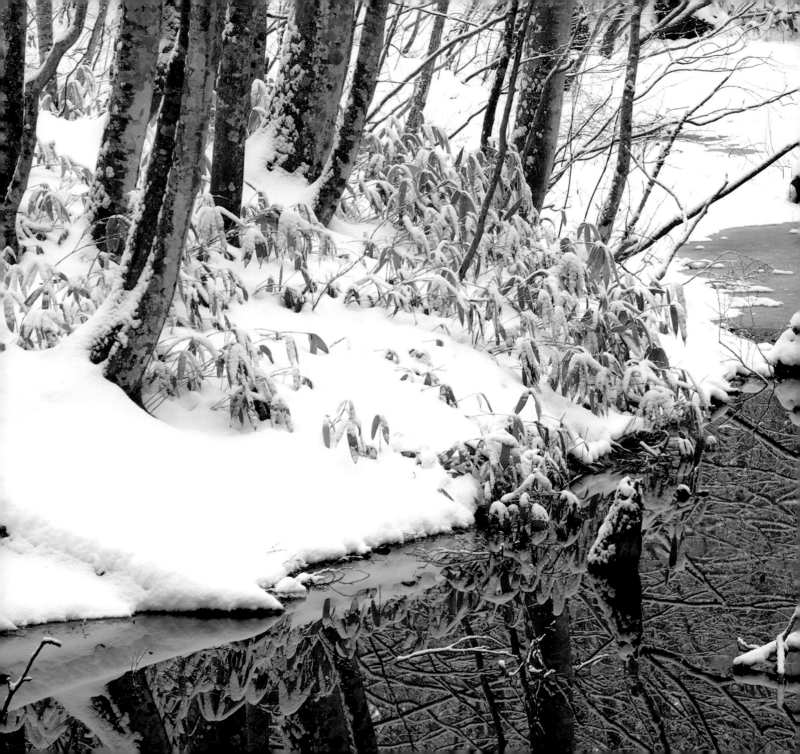

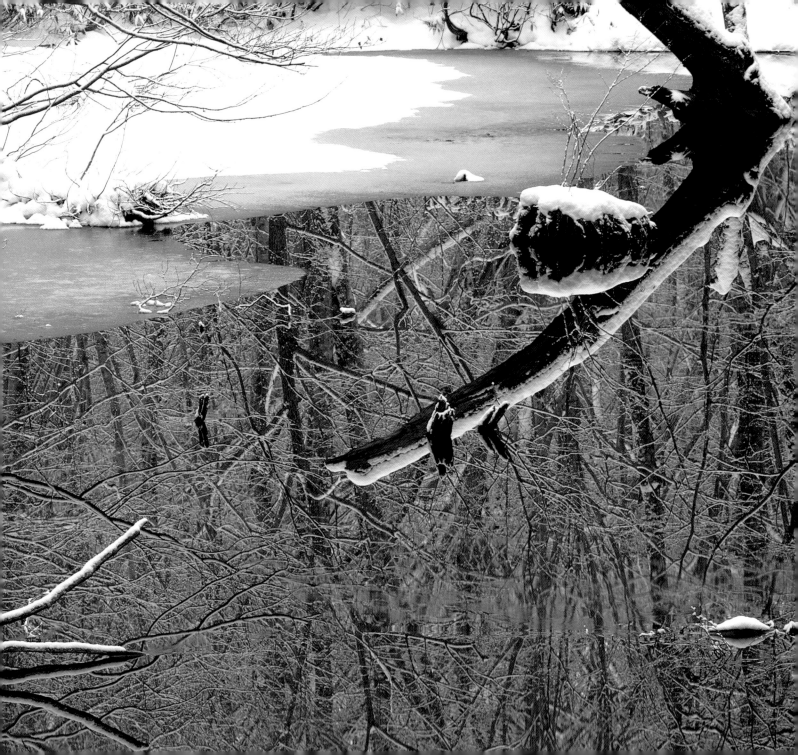

Tsuta Onsen Ryokan

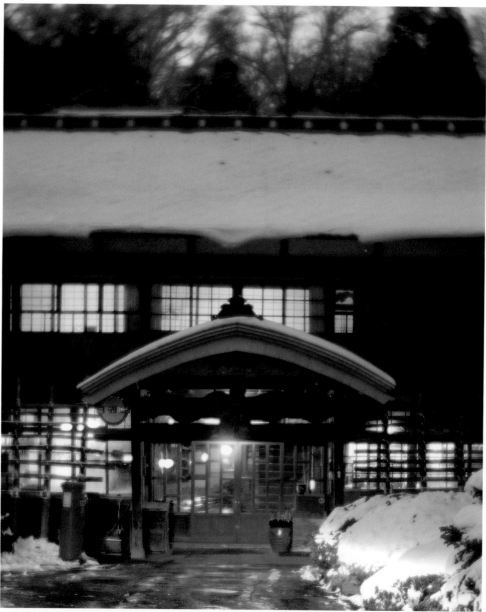

Entrance

(Previous Pages) Aomori: First snow on Tsuta Swamp

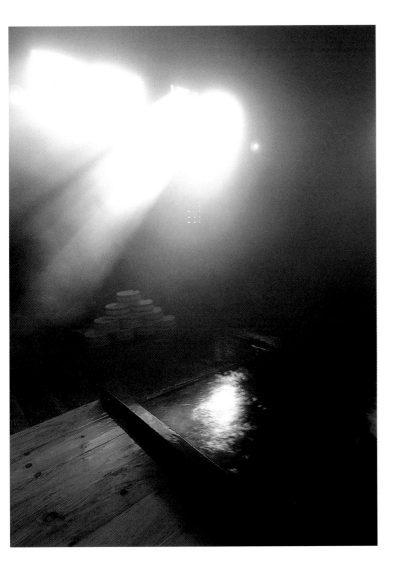
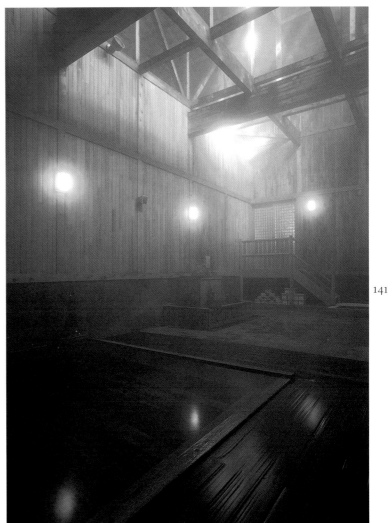

141

(L) Kyuan Bath
(R) Senkyo Bath

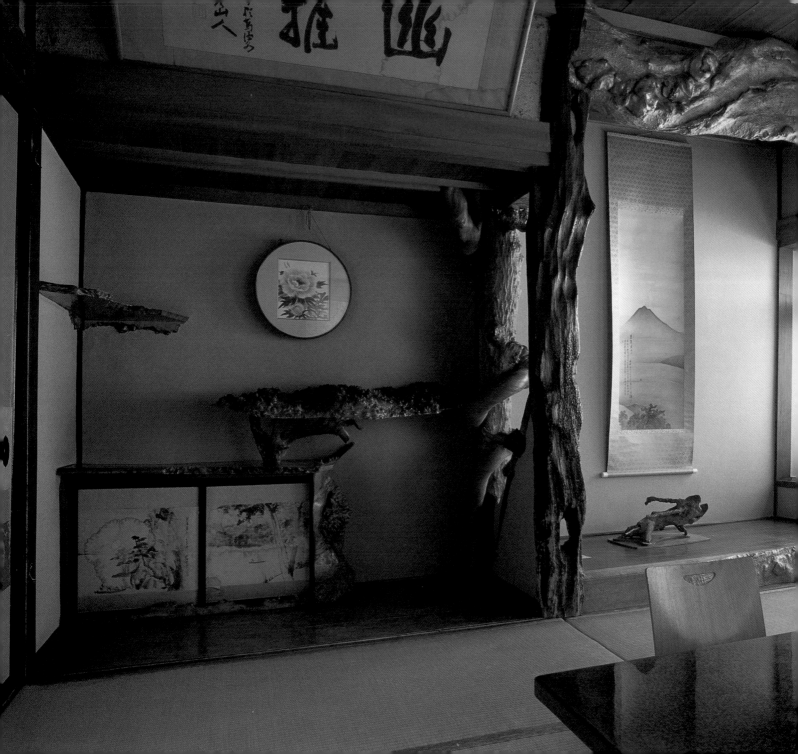

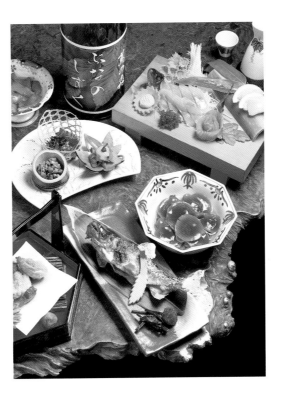

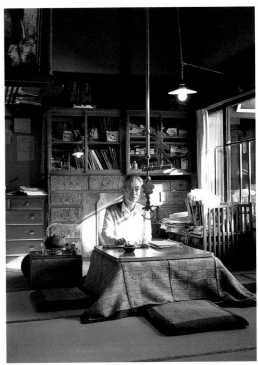

Tsuta Onsen Ryokan: Main Building, Suite No. 21

(L) Tsuta Onsen Ryokan: Locally gathered food
(R) Tsuta Onsen Ryokan: Mr. Ogasawara, owner

Kyoto Byodoin Hoodo

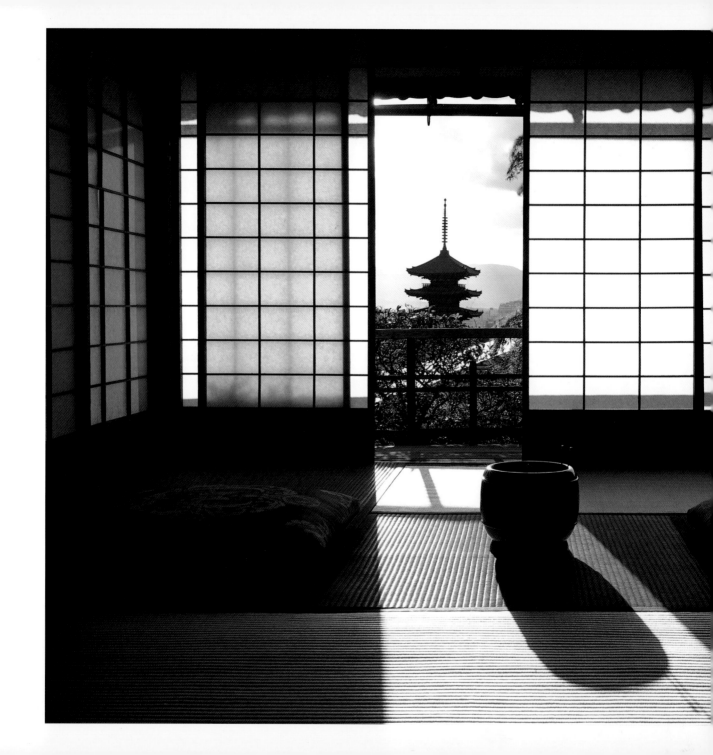

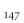

Yasaka Tower, viewed from Soyotei Suite

Kyoyamato: Entrance

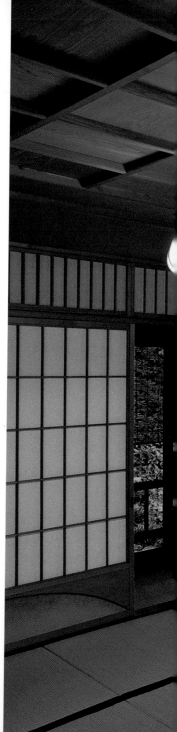

Kyoyamato: Fuki Suite

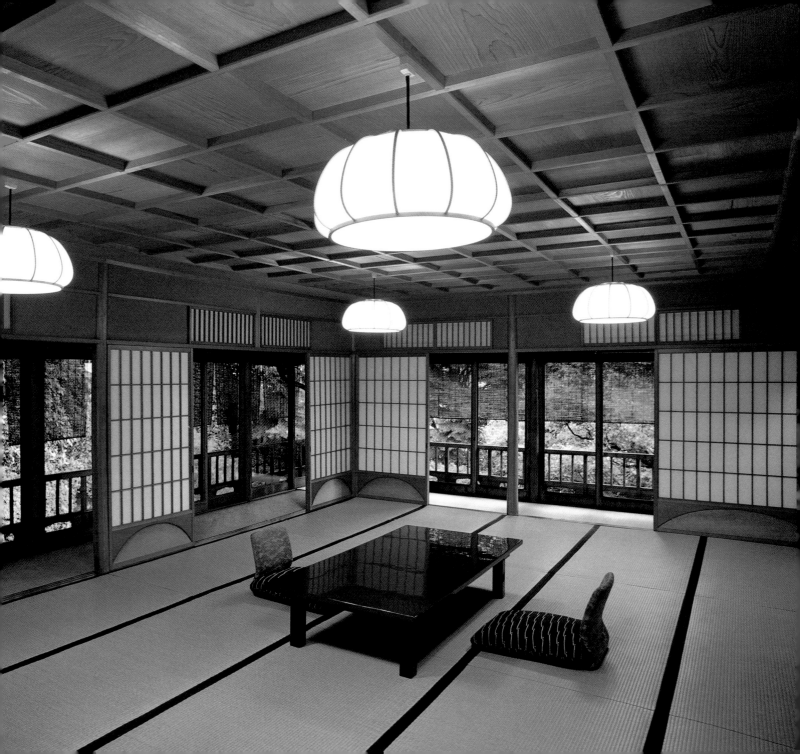

Kyoto Hanase
Miyama-so

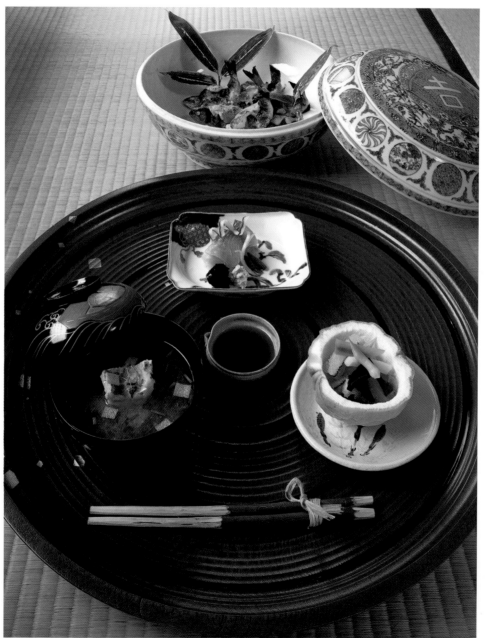

Tsumikusa-style Kaiseki cuisine for early spring

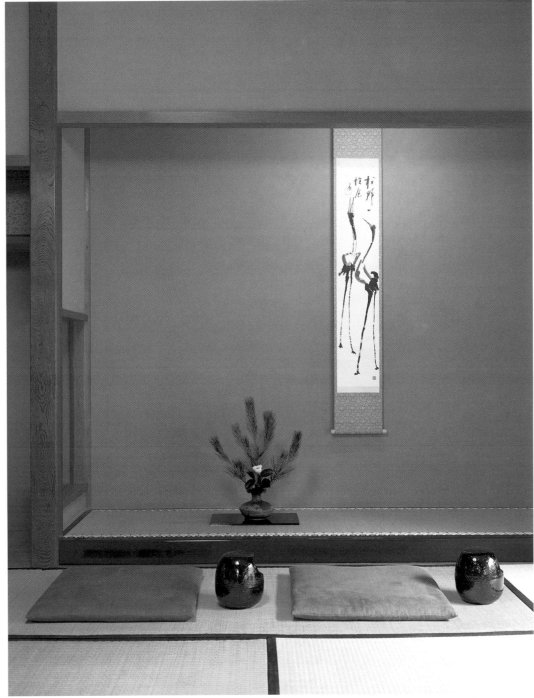

Handwarmers in Winter Suite, decorated for the New Year

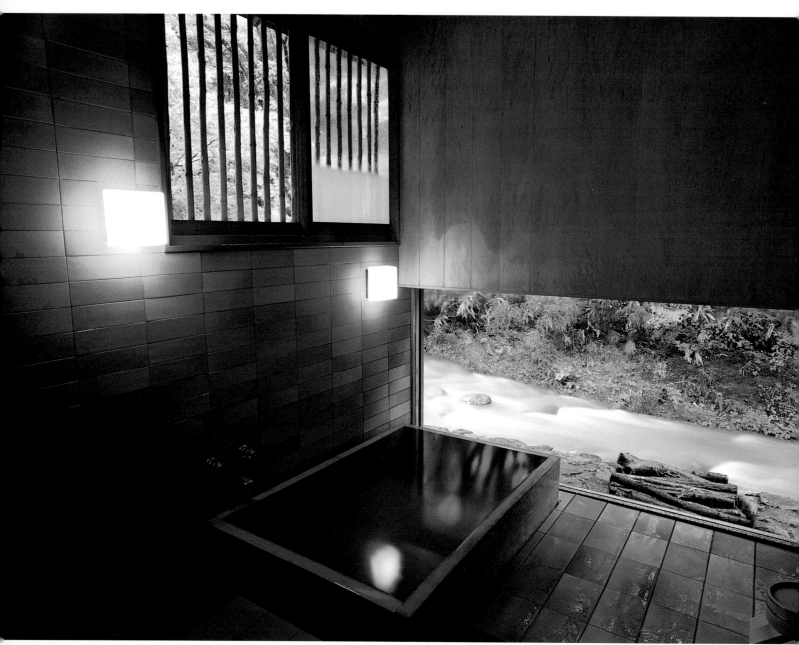

Miyama-so: Bath built from Chinese black pine

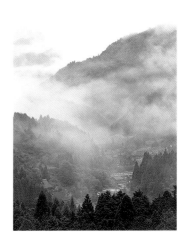

Miyama-so
(L) Autumn Suite
(LC) Hibachi
(RC) Carrying tea from the kitchen to the guest room
(R) Morning mist blanketing Hanase Pass

Yufuin
Kamenoi Besso

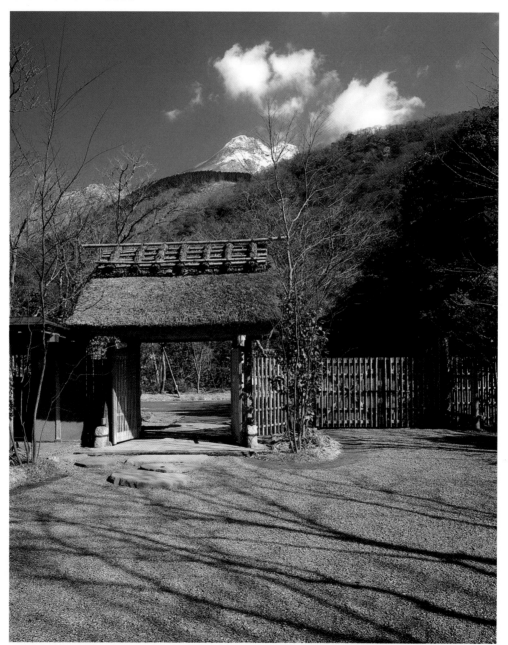

154

Mt. Yufu, viewed from inside the inn's gate

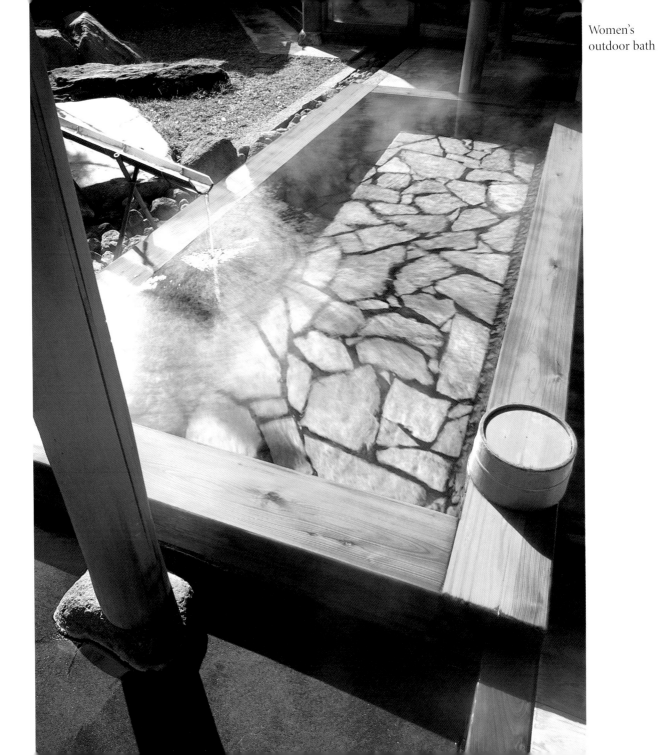

155

156

Kamenoi Besso: The largest annex, Hyakkuban-kan

Kamenoi Besso: Ichiban-kan Suite anteroom

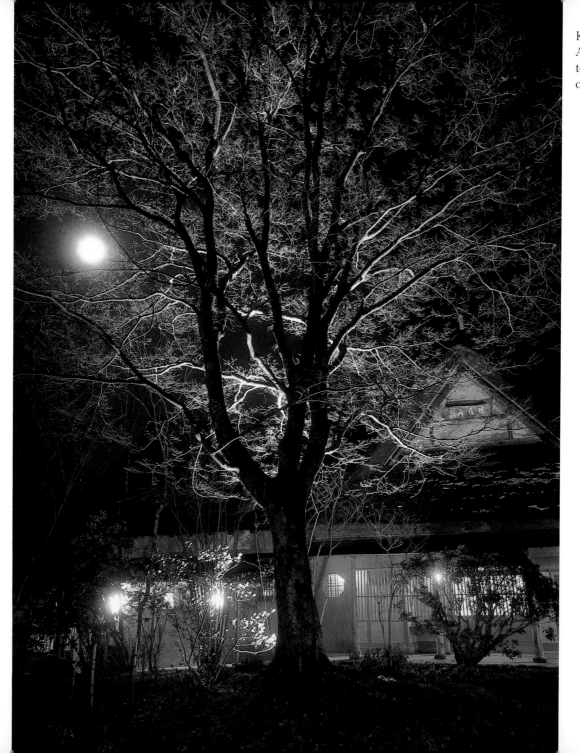

158

Kamenoi Besso:
A tree at the entrance
to the main building
on an autumn night

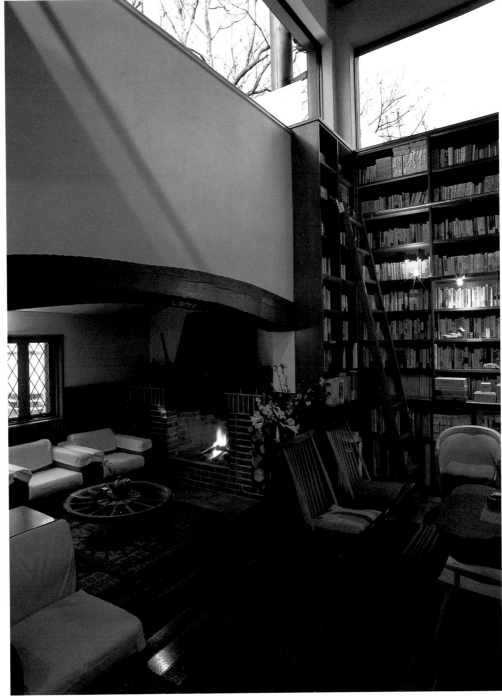

Kamenoi Besso: Lounge

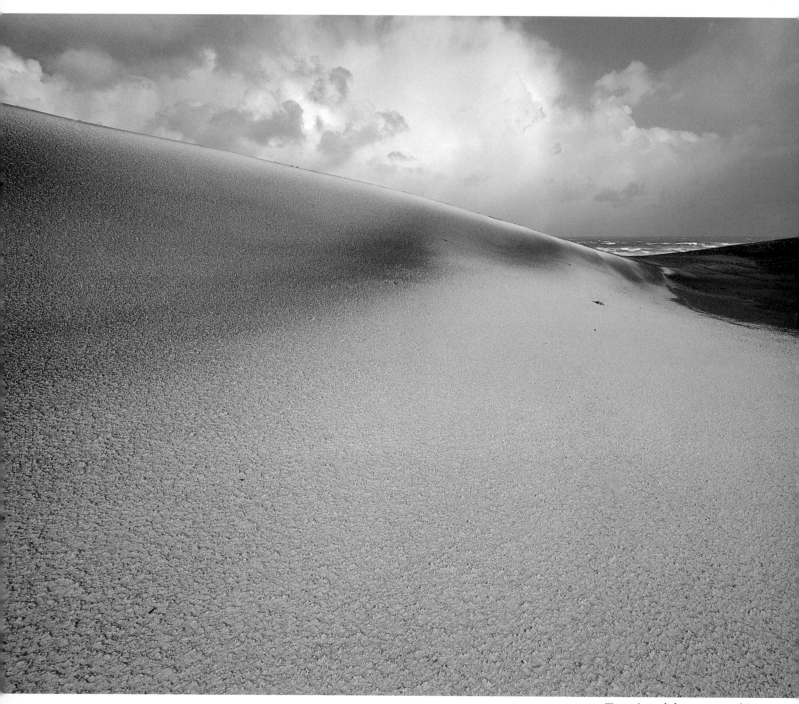

Tottori sand dunes covered in snow

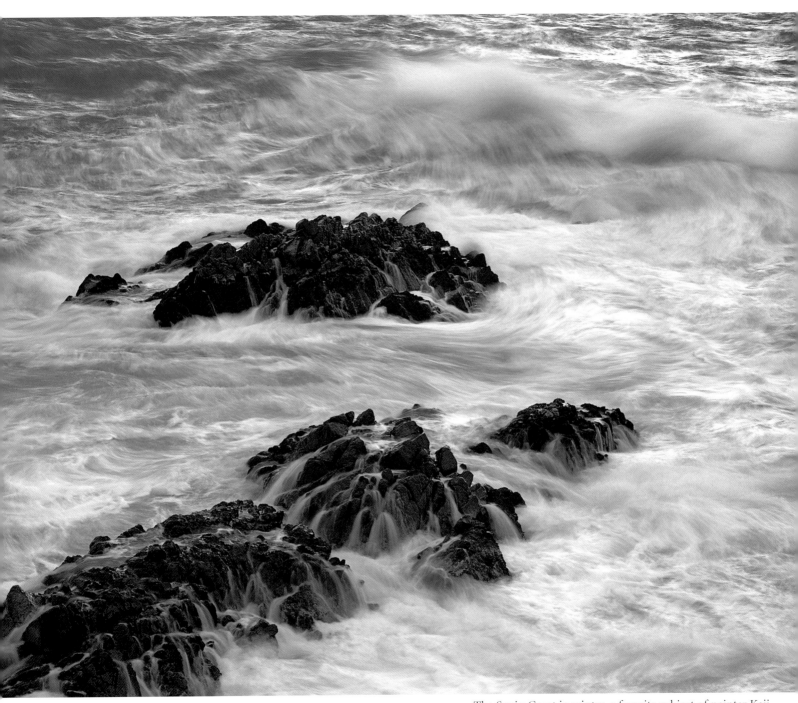

The Sanin Coast in winter, a favorite subject of painter Kaii
Higashiyama

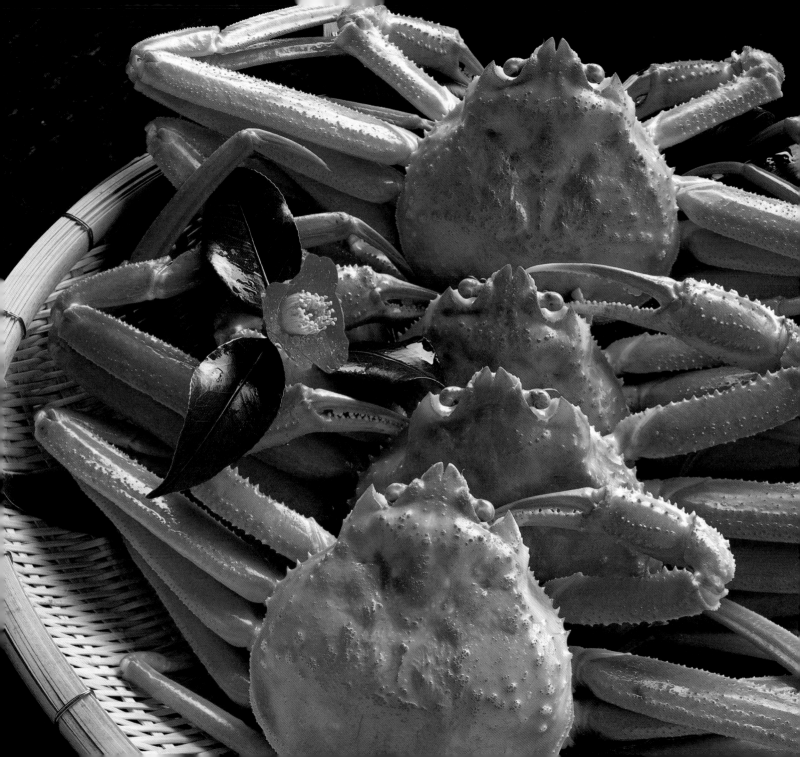

Matsuba crabs, ready for eating

Iwaiya

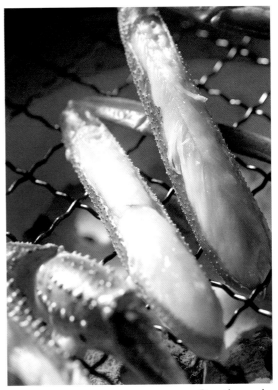

Roasting crabs

163

164

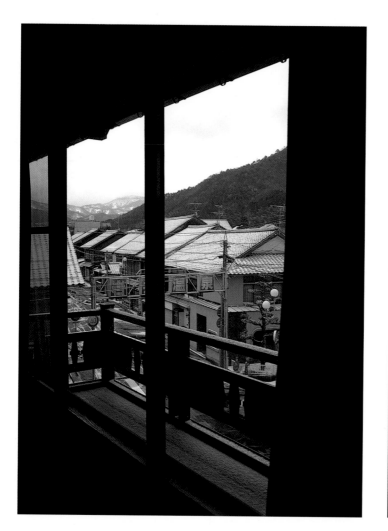

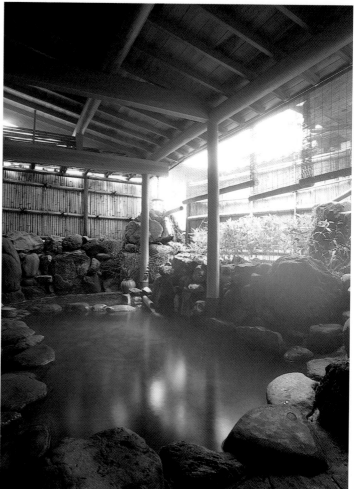

(L) View of the town of Iwai Onsen
(R) Iwaiya: Outdoor hot spring, Seto-no-Yu

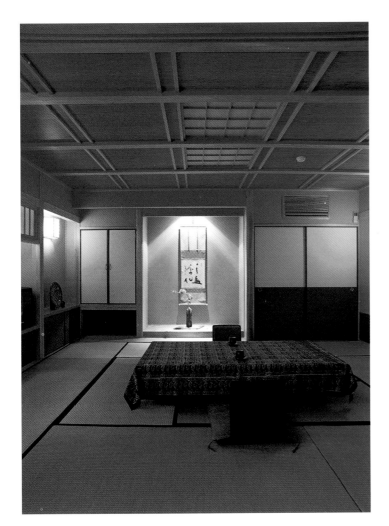

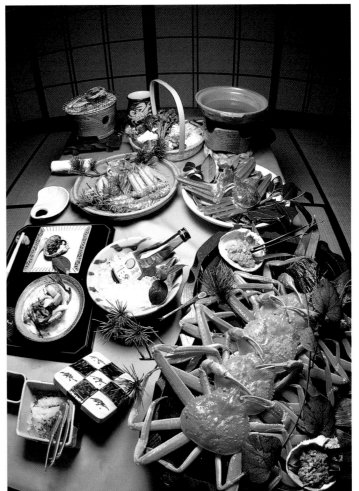

165

(L) Iwaiya: Kobushi Suite
(R) Iwaiya: Crab feast

Ishikawa Yamashiro Onsen
Araya Totoan

Winter scene, viewed from the Ochin Suite

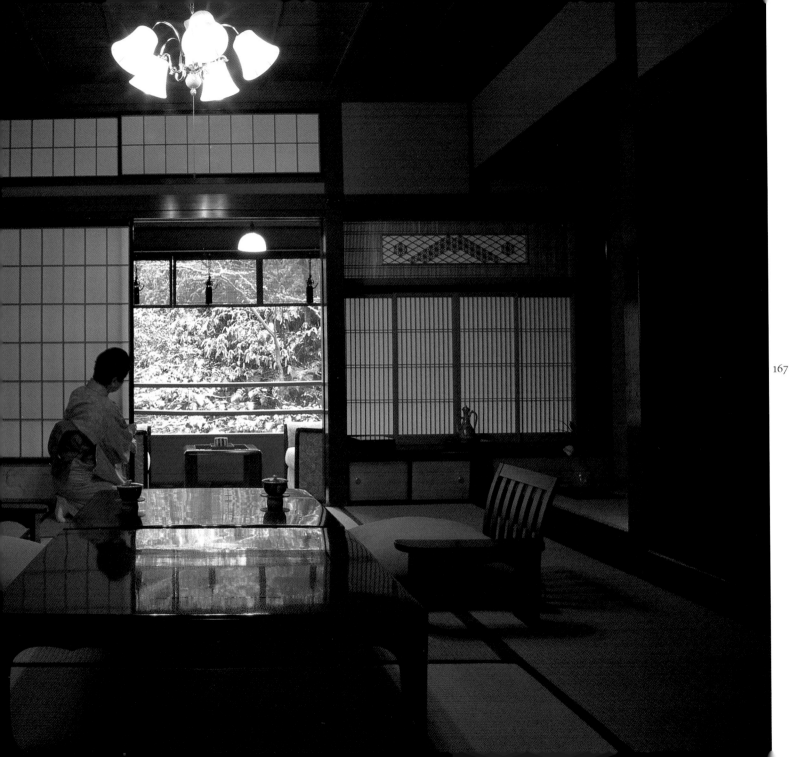

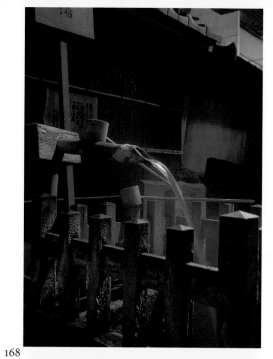

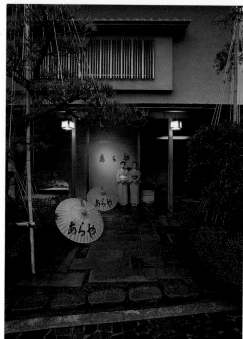

Araya Totoan

(UL) Hot spring mouth at entrance

(UR) Entrance

(BL) Bathing facilities

(BR) "Crow at Dawn," painted by Rosanjin Kitaoji

168

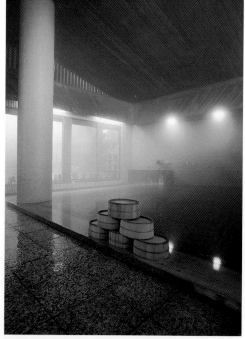

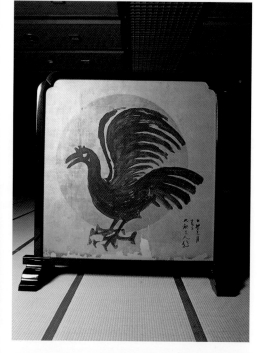

Araya Totoan:
Rosanjin-style meal in a Seika Suda I bowl

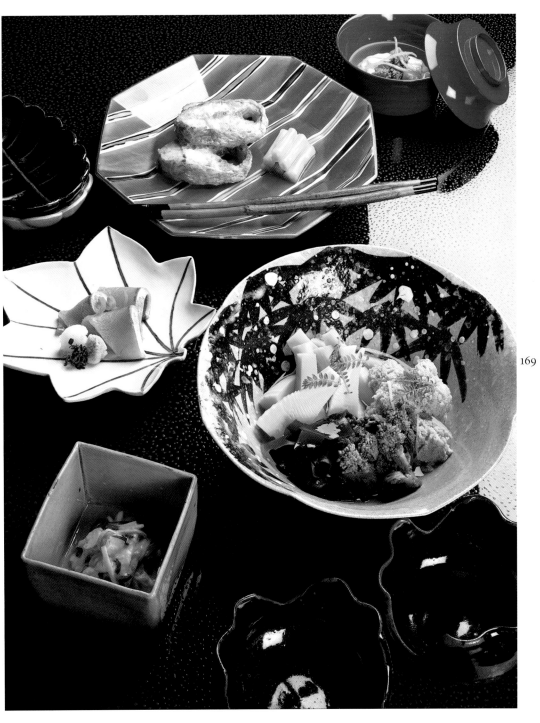

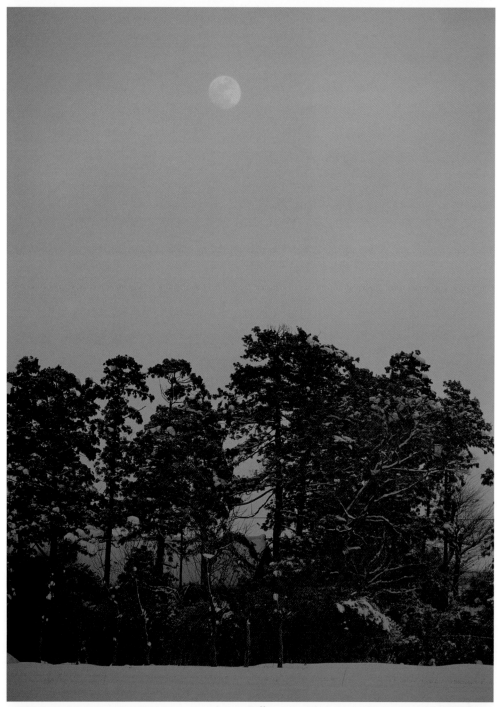

Full moon rising over snow covered Echigo Plain

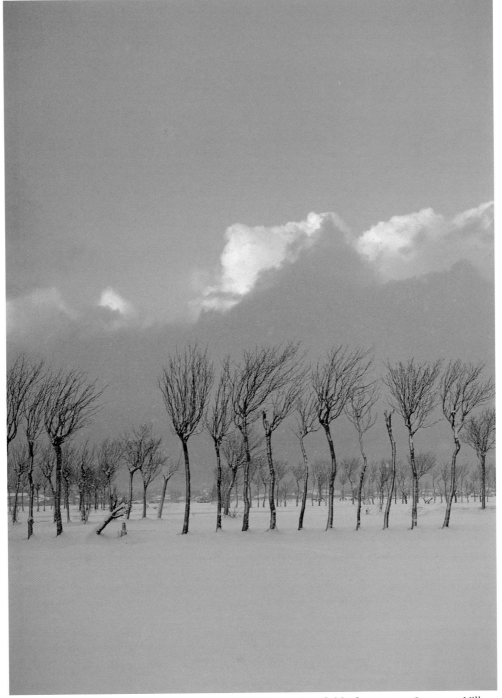

Naked trees in a field of snow near Iwamuro Village

Yumeya

172

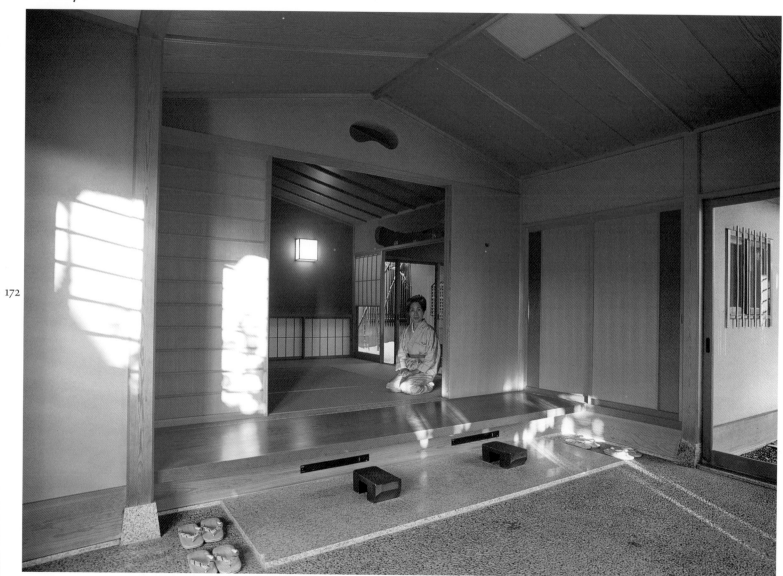

Entrance

Frozen bamboo in
courtyard garden

173

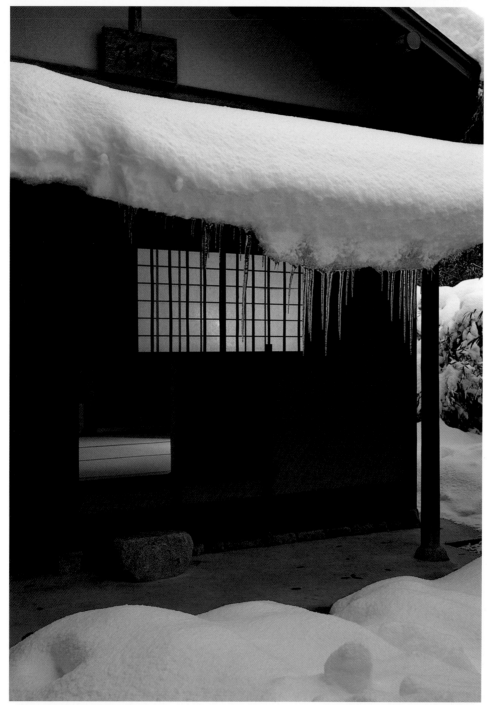

Yumeya: Tea Room

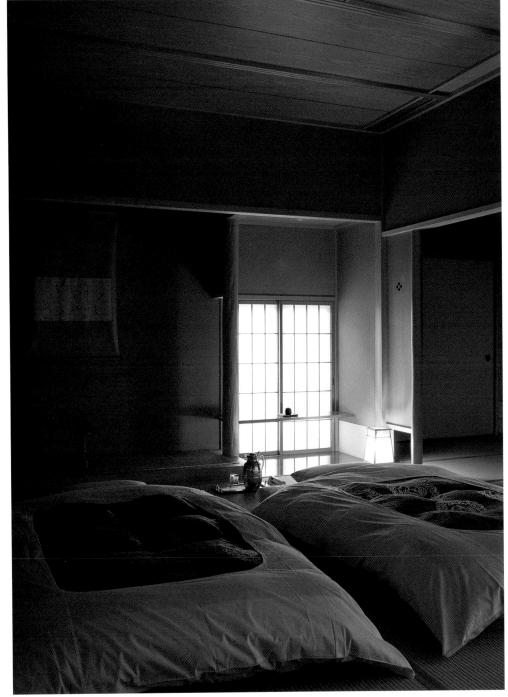

Yumeya: Fern Suite

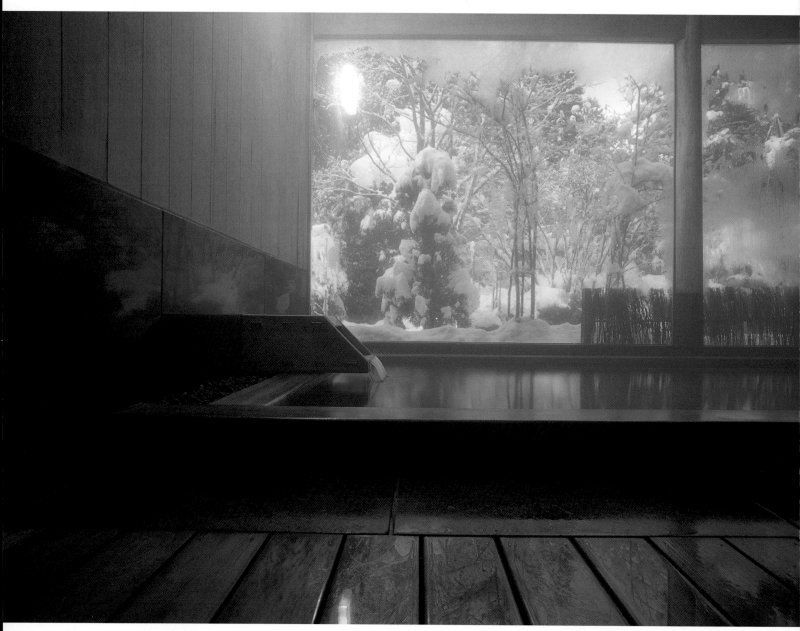

Yumeya: Ancient Chinese black pine bath

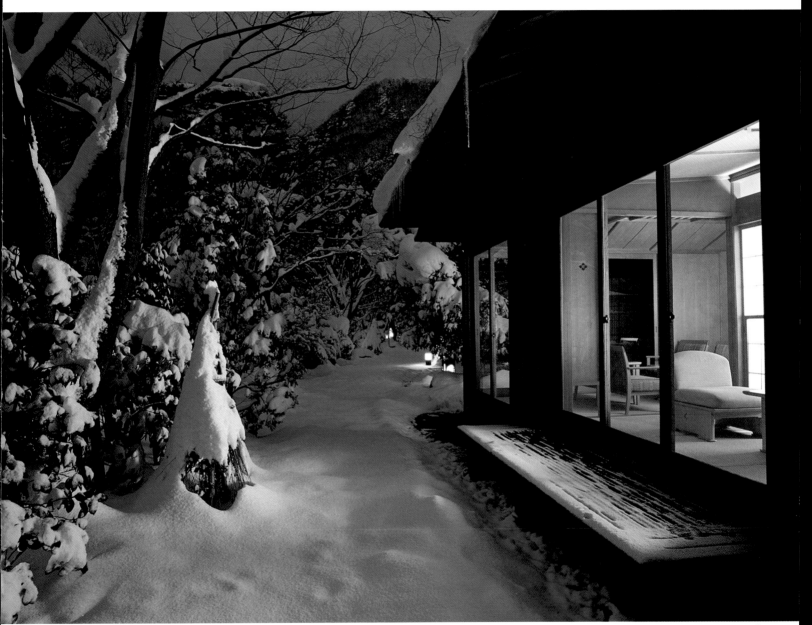

Yumeya: Fern Suite shedding warm light on a snowy garden

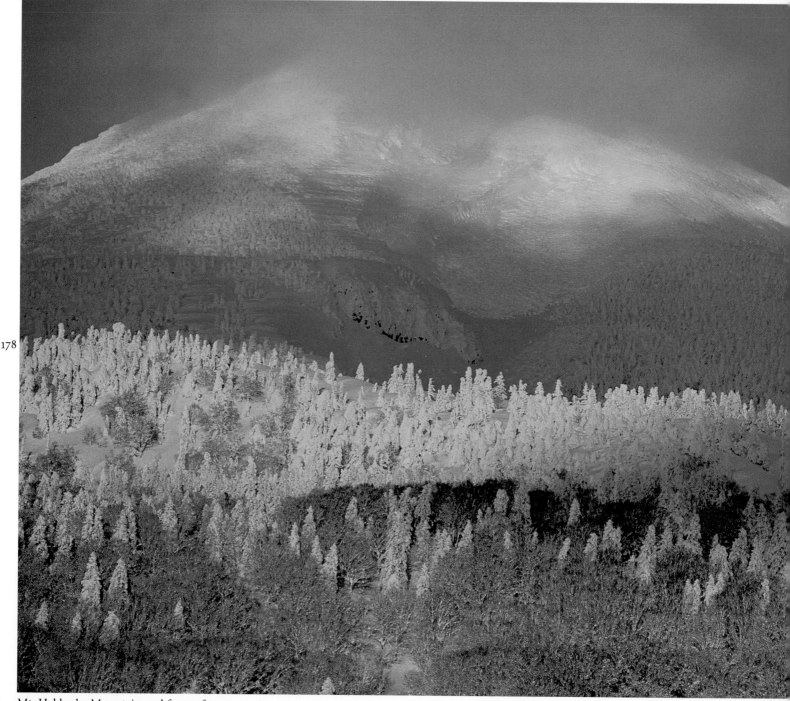

Mt. Hakkoda: Mountain and frozen forest

Hakkoda Hotel

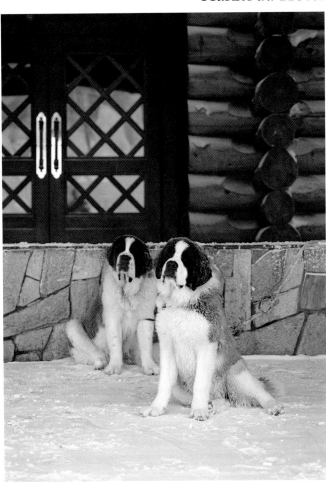

Saint Bernards at the entrance awaiting visitors

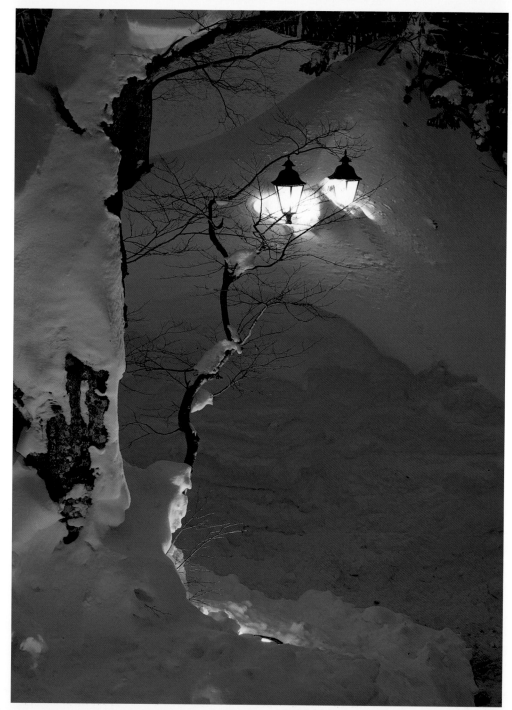

Hakkoda Hotel: Lampposts buried in snow

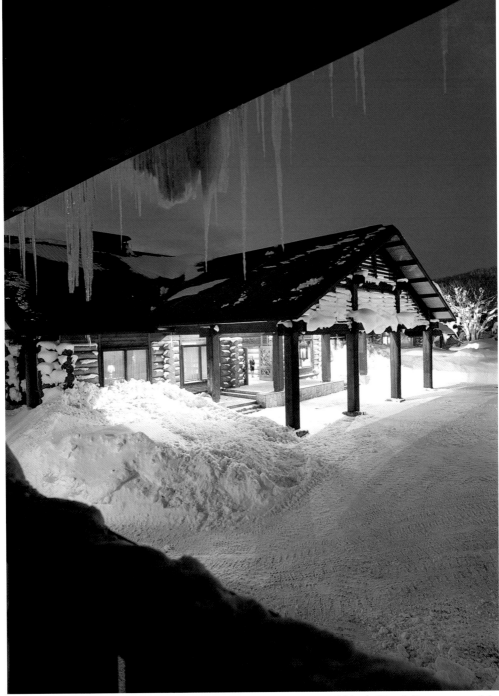

Hakkoda Hotel: Entrance at night

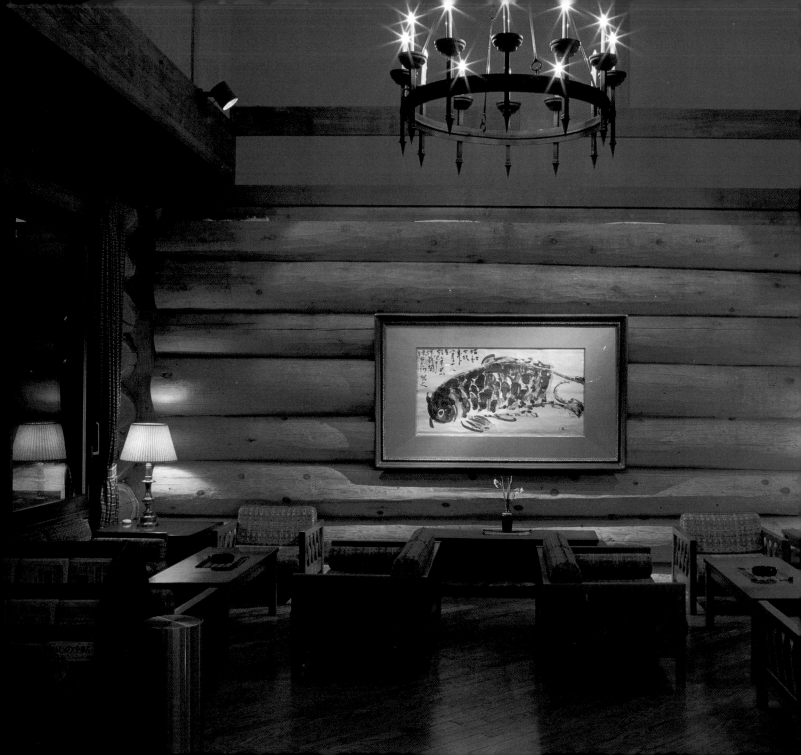

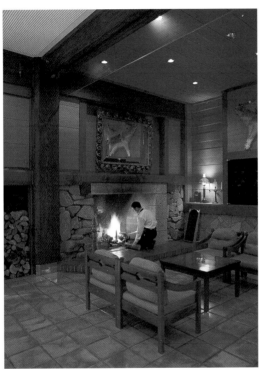

Hakkoda Hotel: Giant artwork by Shiko Munakata in lobby

Hakkoda Hotel
(L) Dining room
(R) Fireplace bar

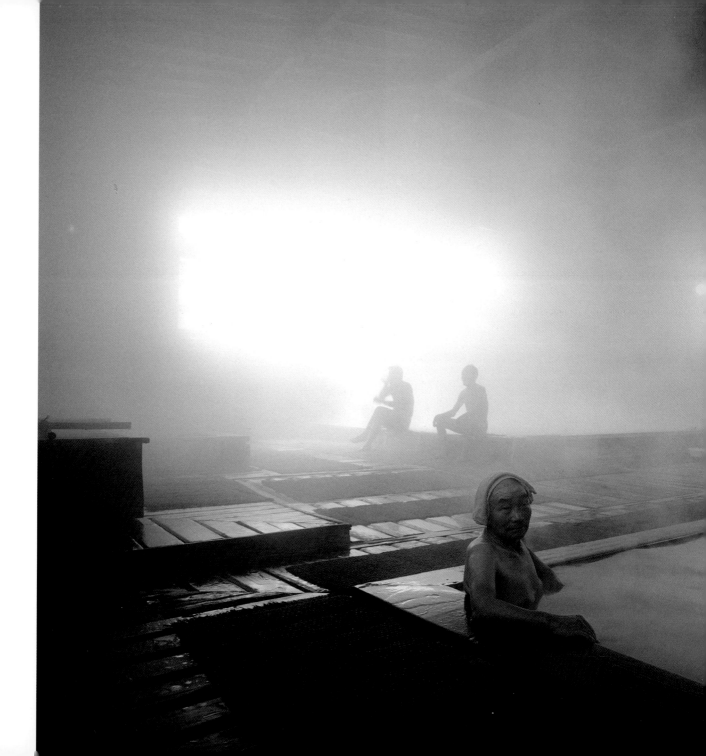

185

Sukayu Hot Spring:
Japanese Cypress Thousand-Man Bath

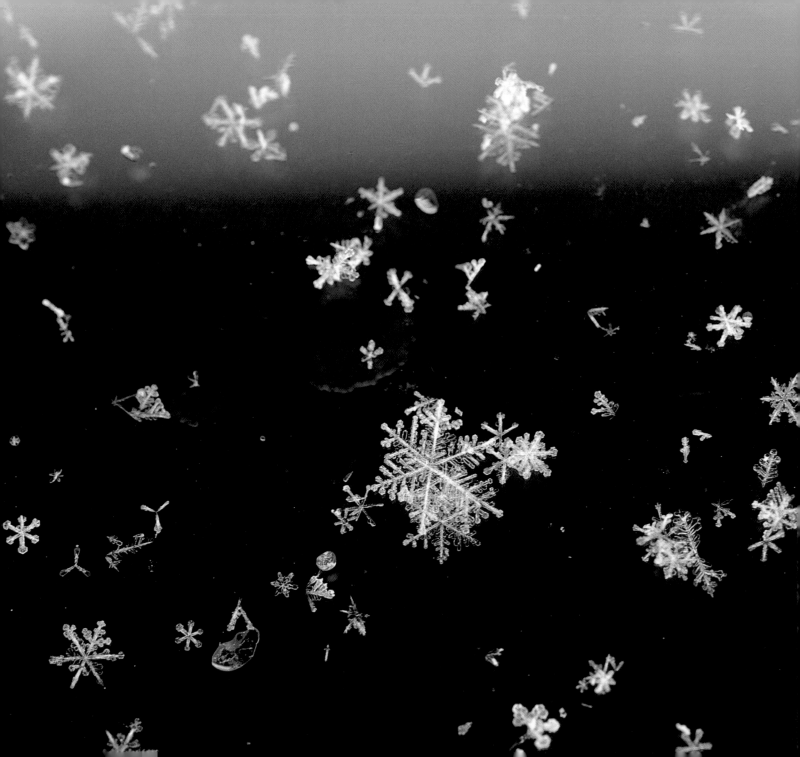

Years ago, I visited the ancient fortress of Masada, which rises up from the arid desert of Israel. As I was buying a ticket for the ropeway from an old woman in a shack, I noticed a ragged picture—apparently torn from a calendar—tacked to a wall. It was a photograph of the moss-covered forests of Yakushima Island. No other place could have evoked the sense of serenity I felt upon viewing this beautiful scene. "Ah, Japan really is a paradise," I thought. Ever since, I have made a point of journeying through Japan, in all its seasons, paying close attention to every detail.

I enjoy experiencing the nature of Japan through the camera's viewfinder, but a certain amount of stress creeps into this pleasure. At these times, I select my lodgings carefully, either to treat myself to a deserved rest or to stir up some excitement. In this book I have gathered thirty of my favorite "paradise resorts," which have afforded me sanctuary over the years. Some are places that I yearn to visit after returning from long trips overseas, while others are new friends.

A true paradise contains water—whether it be hot springs bubbling up from under the earth, the sound of a coursing river, or a moist wind blowing from a lake or forest. Water tempers its surroundings. Maybe that's why uniquely Japanese customs, such as splashing entryways with water or wetting vases and plates for guests, still bring us comfort.

As the soft light filtering through the paper doors of my room envelops me, I become a pupa in its cocoon.

This is the Japan I love.

Kazuyoshi Miyoshi

(Previous Page) Ice Crystals in Hakkoda

GUIDE TO LODGINGS

Kazuyoshi Miyoshi

Data below is accurate as of 6/00

Note : When dialing phone numbers from outside Japan, omit the initial "0".

FUJIYA HOTEL (4-11)

- LOCATION: Kanagawa Prefecture, Ashigarashimo-gun Hakone-machi, Miya-no-shita 359
- PHONE: 0460-2-2211/FAX: 0460-2-2210
- RATES: ¥20,000~¥49,000 (Per person for double-occupancy room w/two meals included. Taxes not included.)
- NUMBER OF ROOMS: 149 (including 3 Japanese-style annex rooms)
- BATHING: Hot springs; 1 family bath (can be reserved); Hot spring-fed bath in each room.
- CHECK-IN: 2:00 p.m./CHECK-OUT: 11:00 a.m.
- ACCESS:
 CAR: 25 minutes from Tomei Highway, Gotenba Interchange, or 20 minutes from Odawara Atsugi Doro, Odawara Nishi exit.
 TRAIN: 7-minute walk from Hakone Tozan Railroad, Miya-no-shita Station.
- HOMEPAGE: http://www.fujiyahotel.co.jp
- E-MAIL: shukuhaku@fujiyahotel.co.jp

A few years ago, I spent eight months photographing Mt. Fuji. My mornings were occupied with taking pictures, and I spent the remainder of these days enjoying the surrounding hot springs and fine foods. The Fujiya Hotel was one of my favorite stops. You can't see Mt. Fuji from the rooms of this hotel, built in 1879, but guests from all over the world used to travel to Lake Ashi-no-Ko in palanquins to view the mountain. The inn hasn't changed since that period; it still reflects the Japanese mystique which charmed foreign guests. The gorgeous dining room in particular looks like a palace (p. 8). It's a good idea to wake up early at least one morning to go see Mt. Fuji bathed in the red light of sunrise. The closest vantage point is the observation point at Daikanyama. From there you can see Mt. Fuji across Lake Ashi-no-Ko; the scene is just like an old Japanese print.

CHIKURININ GUNPOEN (12-17)

- LOCATION: Nara Prefecture, Yoshino-cho, Yoshino-yama
- PHONE: 07463-2-8081/FAX: 07463-2-8088
- RATES: ¥13,000~¥30,000 (Per person for double-occupancy room w/two meals included. Taxes not included.)
- NUMBER OF ROOMS: 55 Japanese-style (including 1 annex room)
- BATHING: 2 communal baths (1 men's and 1 women's); baths in rooms for ¥15,000 and up (34 rooms).
- CHECK-IN: 3:00 p.m./CHECK-OUT: 10:00 a.m.
- ACCESS:
 CAR: One hour from Nishimeihan Highway, Koriyama Interchange.
 TRAIN: Kintetsu Yoshino Line, Yoshino Station, then 10 minutes by taxi.

I've always wanted to see the fabled cherry blossoms of Yoshino, but I've never managed to time my visit right. The blossoms here aren't as showy as Somei Yoshino's cherry trees, but the sight of the entire mountainside covered in vibrant, white, mountain cherry trees certainly makes for some of the best cherry blossom viewing in Japan (pp. 12-13). The nicest place to stay in Yoshino would have to be Chikurinin Gunpoen; ancient warlord Hideyoshi chose it for his lodgings. The gold-leaf bento box he used on that historic occasion remains on display. From the Pine Room, where the Showa emperor himself slept, you can view the gorgeous mountains beyond and the garden that legendary tea master Sen-no-Rikkyu is said to have tended.

WA-NO-SATO (18-23)

- LOCATION: Gifu Prefecture, Oono-gun, Miyamura,oku 1682
- PHONE: 0577-53-2321/FAX: 0577-53-3220
- RATES: ¥30,000~¥50,000 (Per person for double-occupancy room w/two meals included. Taxes not included.)
- NUMBER OF ROOMS: 8 (with 4 annex rooms: each in a separate cottage)
- BATHING: 2 indoor hot springs (men and women switch morning and evening); baths in each room.
- CHECK-IN: 3:00 p.m./CHECK-OUT: 11:00 a.m.
- ACCESS:
 CAR: 60 minutes from Tokai Hokuriku Highway, Shokawa Interchange.
 TRAIN: Takayama Honsen Line, Takayama Station. A car will meet you at the station (advance notice required); 20 minutes by taxi.

Usuzumizakura (literally: "cherry tree the color of faint ink") is probably Japan's most famous cherry tree. I read about it in Chio Uno's novel, but wanted to see it for myself. It was recently in danger of dying, but is now more splendid than ever. You aren't allowed close enough to actually touch it, but I was relieved to see budding green shoots along its branches. If you want to see this magnificent tree, I recommend staying at the relatively nearby Wa-no-Sato in Hidatakayama. This old Japanese farmhouse has been moved and rebuilt into a fine, luxurious inn.

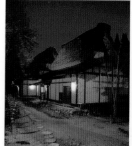

MINATOYA (24-29)

- LOCATION: Nagano Prefecture, Suwa-gun, Shimo suwa-machi Tatu-machi 3532
- PHONE/FAX: 0266-27-8144
- RATES: ¥18,000 (Per person for double-occupancy room w/two meals included. Tax, service included.)
- NUMBER OF ROOMS: 5
- BATHING: 1 outdoor hot-spring bath (can be reserved).
- CHECK-IN: 4:00 p.m./CHECK-OUT: 10:00 a.m.
- ACCESS:
 CAR: 10 minutes from Chuo Highway, Okaya Interchange or Suwa Interchange.
 TRAIN: 10-minute walk from Chuo Honsen Line, Shimo Suwa Station. (Note: Not all express trains stop at Shimo Suwa Station, although some do. For trains that do not stop at Shimo Suwa, change to a local train at Kami Suwa Station.)

I set forth from the Minatoya Inn to greet the oldest cherry tree in Japan. According to legend, it was planted by the god Yamato Takeru-no-Mikoto, and was once saved from death by Saint Nichiren. The 1,800-year-old tree, named Yamataka Jindaizakura, stands on the grounds of the Jissoji Temple, in Yamanashi Prefecture. I don't think it's possible for anyone to view the delicate pink blossoms on this ancient black giant and walk away unchanged. It takes a certain amount of preparation to meet a venerable tree like this. Minatoya is a little far away, but fits the bill perfectly. I lay in the inn's bath, the bottom strewn with white pebbles, and dreamed of falling petals.

TSURU-NO-YU ONSEN (30-33)

- LOCATION: Akita Prefecture, Senpoku-gun Tazawa ko-machi Tazawa, Aza Sendatsuzawa Kokuyurin 50
- PHONE: 0187-46-2139/FAX: 0187-46-2761
- RATES: ¥8,000~¥15,000 (Per person for double-occupancy room w/two meals included. Taxes not included.)
- NUMBER OF ROOMS: 30 (plus 9 in Yama-no-Yado annex)
- BATHING: 8 indoor hot springs (4 men's and 4 women's); 3 outdoor hot springs (1 mixed and 2 women's).
 Annex: 3 indoor hot springs (1 men's, 1 women's, 1 mixed); private baths in rooms
- CHECK-IN: 3:00 p.m./CHECK-OUT: 10:00 a.m.
- ACCESS:
 CAR: : 80 minutes from Tohoku Highway, Morioka Interchange.
 TRAIN: Akita Shinkansen Line, Tazawako Station. Take Nyuto Onsen bus from Tazawako Station and get off at Tazawako Kogen Onsen. 10 minutes by complimentary shuttle from Tazawako Kogen Onsen (phone for pick-up from Tazawako Kogen Onsen upon arrival).

Spring in northern Japan is dramatic. Hiding from the bright rays of the spring sun, deep snow remains under the new growth. Snow melts from around the trunk of a beech tree whose trunk has been gradually shaped by the snow's weight (p. 31). Dakedai is a forest grove easily accessible to visitors within the Shirakamisanchi (p. 30), which has been designated a World Heritage Site. The splendor of this pristine beech forest awes me. It would be unthinkable to visit these mountains without experiencing the hot springs, so I pay a visit to Tsuru-no-Yu. Its waters are milky white, so one doesn't mind that men and women bathe together. Originally, there was a small spare room built for those who came for Tsuru-no-Yu's medicinal properties, but now magnificent accommodations are available. The pleasures to be had at this hot spring are no longer limited to the waters.

AONI ONSEN (34-35)

- LOCATION: Aomori Prefecture, Kuroishi-shi, Okiura Aonisawa Taki-no-ue
- PHONE: 0172-54-8588/FAX: 0172-54-2655
- RATES: ¥8,500 (April~November); ¥10,000 (December~March) (Per person for double-occupancy room w/two meals included. Taxes not included.) Note: The rate rises during the winter due to snow, and may extend into April after particularly heavy snowfall.
- NUMBER OF ROOMS: 33 (with 11 annex rooms)
- BATHING: 3 indoor hot springs (1 mixed, 1 men's and 1 women's); 1 outdoor hot spring (mixed).
- CHECK-IN: 3:00 p.m./CHECK-OUT: 10:00 a.m.
- ACCESS:
 CAR: 40 minutes from Tohoku Highway, Kuroishi Interchange.
 (In winter, leave car at Nijinoko Koen near Aseishi Dam, about halfway between Kuroishi Interchange and Aoni. A snowmobile will come to pick you up (reservation required)).
 TRAIN: Konan Tetsudo Line, Kuroishi Station. Complimentary shuttle arrives at 10:00 a.m. and 4:00 p.m. (reservations required)
 Taxi: 40 minutes from Kuroishi Station; 60 minutes from Aomori Airport.

During my stay here, for the first time in my life, I lived solely by the light of an oil lamp. I find it sharpened my senses, so that the sounds of the river and the forest denizens penetrated more deeply. When I crossed the hanging bridge and immersed myself in the large outdoor hot spring, the world and its worries disappeared. I felt as though I had entered a hot spring for the first time. Afterward, I ate by the fireside. I also like that the staff come to greet you in a snowmobile in the winter!

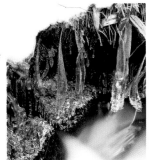

KAMIKOCHI IMPERIAL HOTEL (36-45)

- LOCATION: Nagano Prefecture, Minami Azumi-gun Azumi Mura, Kami Kochi
- PHONE: 0263-95-2006 (during business season) or 03-3592-8001 (off-season)/FAX: 0263-95-2412/03-3539-8139
- RATES: ¥26,500~¥41,000 (Double-occupancy room. Taxes not included. Open from the end of April to the middle of November.
(Rates for room, not per person; no meals. Suite with two bedrooms (up to four people), ¥92,000]
- NUMBER OF ROOMS: 75
- BATHING: Bath in each room.
- CHECK-IN: 2:00 p.m./CHECK-OUT: 11:00
- ACCESS:
CAR: 60 minutes to Sawando from Nagano Highway, Matsumoto Interchange. Because cars are regulated, you must board a bus or a taxi from the Sawando parking lot.
TRAIN: Matsumoto Dentetsu to Shin Shimashima Station (final stop). Board bus to Kami Kochi and get off at Kami Kochi Teikoku Hotel (60 minutes).
- LIMOUSINE: From Tokyo (round trip ¥160,000).
- HOMEPAGE: http://www.imperialhotel.co.jp
- E-MAIL: kamikochi@imperialhotel.co.jp

I never get tired of Taisho Pond at sunrise (pp. 36-37). Only the hotel guests have the privilege of taking in the majestic mountains and the gradations of the pond's surface as it changes throughout the day. From here, the congestion at Kappa Bridge seems imaginary. The Kami Kochi Imperial Hotel only operates from the end of April to the middle of November, from the time Tashiro Pond buds with the first growth of the year to the time it is covered by the winter's first frost (pp. 38-39). Nature changes so drastically in a mere six months. The hotel's service rates with Tokyo's finest, but in the city, you can't spend the afternoon on a terrace gazing at mountain peaks. I also recommend venturing out to visit Myojin Pond.

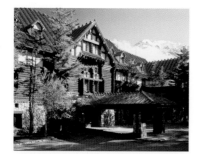

GENMYOAN (46-49)

- LOCATION: Kyoto-fu, Miyazu-shi, Aza Monju 32
- PHONE: 0772-22-2171/FAX: 0772-25-1641
- RATES: ¥25,000~¥50,000 (Per person for double-occupancy room w/two meals included. Taxes not included.)
- NUMBER OF ROOMS: 28
- BATHING: 2 indoor baths (1 men's and 1 women's); baths in all rooms.
- CHECK-IN: 3:00 p.m./CHECK-OUT: 11:00
- ACCESS:
CAR: 50 minutes from Maizuru Highway, Maizuru Nishi Interchange or Fukuchiyama Interchange.
TRAIN: Kita Kinki Tango Rail to Ama-no-Hashidate Station. 5 minutes by shuttle (reservation required).

I took a trip to Ama-no-Hashidate to see one of nature's most mysterious creations. I was impressed by its scale. And yet, I think it's better appreciated from above than up close. Genmyoan sits in the perfect vantage point for this, perched as it is above the bay. Having one of Japan's three most famous views in front of me when I go to sleep and wake up is like a dream itself. Just one big sheet of glass and an automatic curtain separates me from Ama-no-Hashidate (pp. 46-47). The unforgettable kyo-kaiseki cuisine, modeled on ancient Kyoto court cuisine, takes advantage of the freshest fish from Miyazu Harbor.

YOYOKAKU (50-53)

- LOCATION: Saga Prefecture, Karatsu-shi, Higashi Karatsu 2-4-40
- PHONE: 0955-72-7181/FAX: 0955-73-0604
- RATES: ¥15,000~¥35,000; From 11/2~11/4 and 12/31~1/4, rates are ¥20,000~¥40,000.) (Per person for double-occupancy room w/two meals included. Taxes not included.)
- NUMBER OF ROOMS: 22
- BATHING: 2 indoor baths (1 men's and 1 women's); baths in 18 rooms.
- CHECK-IN: 3:00 p.m./CHECK-OUT: 11:00
- ACCESS:
CAR: 35 minutes from Nagasaki Highway, Taku Interchange.
TRAIN: Karatsu Line or Chikuhi Line to Karatsu Station; 7 minutes by taxi.
- HOMEPAGE: http://www.matsuronet.ne.jp/yoyokaku/
- E-MAIL: yoyokaku@matsuronet.ne.jp

One of the aspects that makes this inn so special is the collaboration between the owner and potter Takashi Nakazato. The superb use of pottery in its many forms is endlessly fascinating. Cuisine and plates, flowers and vases—a delicate balance is achieved throughout. In the garden, I relished the salt air blowing from the ocean beyond the pines. The seafood in the inn's meals is delightful, as is the inn's famous zaru-tofu breakfast.

CHIMIKEPPU HOTEL (54-57)

- LOCATION: Hokkaido, Abashiri-gun Tsubetsu-cho, Aza Numasawa 204
- PHONE: 01527-7-2121/FAX: 01527-7-2100
- RATES: ¥36,000~¥48,000 (Double-occupancy room. Breakfast included. Taxes not included.)
- NUMBER OF ROOMS: 9
- BATHING: Bath in each room.
- CHECK-IN: 3:00 p.m./CHECK-OUT: 10:00 a.m.
- ACCESS:
 Taxi: 60 minutes from Memanbetsu Airport (no shuttle).

Chimikeppu is a quiet lake surrounded by a primeval forest. Walking beneath the giant oaks, firs, and spruces, I felt quite small. Covered in early-morning mist, the lake is a fine sight—so romantic that it's hard to imagine that it's the same place during the day. The view of the lake from the rooms, not to mention the surrounding unspoiled wilderness, make this hotel truly one of a kind.

YAKUSHIMA IWASAKI HOTEL (58-63)

- LOCATION: Kagoshima Prefecture, Kumage-gun Yaku-cho Onoaida 1306
- PHONE: 09974-7-3777/FAX: 09974-7-3788
- RATES: ¥17,000~¥26,400; The range of rates is related to the season, not the type of room. (Per person for double-occupancy room w/two meals included. Taxes not included.)
- NUMBER OF ROOMS: 123
- BATHING: 2 indoor hot springs (1 men's and 1 women's); 2 outdoor hot springs (1 men's and 1 women's); baths in all rooms.
- CHECK-IN: 2:00 p.m./CHECK-OUT: 11:00 a.m.
- ACCESS:
 TAXI: 30 minutes from Yakushima Airport.

Yakushima is one of my favorite places in Japan these days. I've been there more than ten times, and I still enjoy it immensely. First, I recommend venturing into the forest to experience nature by yourself. Next, stay at one of the rooms on the mountain side of the Yakushima Iwasaki Hotel, at the base of Mocchomu Mountain (p. 60). The moment you step into your room you will be enveloped in the deep green of the cedars (p. 62). After a day, you'll begin to feel yourself a part of this primeval forest. On the other side of the hotel, the Pacific Ocean lies before you (p. 61). The contrast is one of this lodging's charms—as are the fresh local ingredients in the meals served here and at the local hot springs.

HOTEL NIKKO ARIBIRA (64-67)

- LOCATION: Okinawa Prefecture, Nakagami-gun Yomitan-son, Gima 600
- PHONE: 098-982-9111/FAX: 098-958-6620
- RATES: ¥35,000 and up, depending on the season (Per person for double-occupancy room w/two meals included. Taxes not included.)
- NUMBER OF ROOMS: 400
- BATHING: Baths in all rooms
- CHECK-IN: 2:00 p.m./CHECK-OUT: 11:00 a.m.
- ACCESS:
 TAXI/SHUTTLE: 60 minutes from Naha Airport. BUS and TAXI: Go to the Naha bus terminal from the airport and board a Yomitan Line, Yomitan-bound bus and get off at Ufudo. 5 minutes from there by taxi.
- HOMEPAGE: http://www.ryukyu.ne.jp/~aribira
- E-MAIL: aribira@ryukyu.ne.jp

I still remember the shock of viewing the emerald-green waters of Okinawa for the first time, even though I was only in the second grade. Since then, I've seen oceans all over the world, but I still think Okinawa's shore is the finest. The bountiful coral and tropical fish make you feel as though you've stepped into a fairy tale. The Hotel Nikko Aribira feels more like a foreign resort than a Japanese hotel. The view of the sea from the rooms is terrific (p. 67). The Japanese restaurant Sawa serves food you wouldn't find on the mainland. (pp. 64-65). Think of it as Japanese fusion.

ARAI RYOKAN (68-71)

- LOCATION: Shizuoka Prefecture, Tagata-gun Shuzenji-cho Shuzenji 970
- PHONE: 0558-72-2007/FAX: 0558-72-5119
- RATES: ¥23,000 and up (Per person for double-occupancy room w/two meals included. Taxes not included.)
- NUMBER OF ROOMS: 36 (with 1 annex room)
- BATHING: 1 outdoor hot springs (men and women switch); 1 indoor hot spring (men and women switch); 1 exposed hot spring (men and women switch); 2 family baths (can be reserved); baths in 19 of the rooms (all private baths are fed by hot springs)
- CHECK-IN: 3:00 p.m./CHECK-OUT: 11:00 a.m.
- ACCESS:
 CAR: 45 minutes from Tomei Highway, Numazu Interchange.
 TRAIN: Izu Hakone Line or Odoriko Line to Shuzenji Station; 5 minutes by taxi.

Inside the elegant bathhouse Tempyo Daiyokudo, you feel as if you are taking a bath in the ancient temple Horyuji. The bathhouse was built and named by Yukihiko Yasuda. When it was newly constructed, this rustic inn was favored by literary and artistic figures of the time, such as Taikan Yokoyama and Kido Okamato. The garden is built around a giant zelkova tree (p. 69). Water from the Katsura river flows under one of the building's corridors. Like a Tahitian hut built on stilts, this inn truly makes one feel the presence of water.

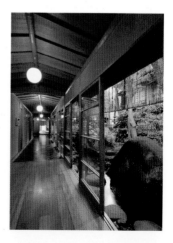

SHIGETSU (72-77)

- LOCATION: Kanagawa Prefecture, Ashigarashimo-gun Yugawara-machi, Miyakami 684-14
- PHONE: 0465-63-8686/FAX: 0465-63-8687
- RATES: ¥30,000~¥50,000 (Monday~Thursday); ¥35,000~¥55,000 (Friday~Sunday) (Per person for double-occupancy room w/two meals included. Taxes not included. New Year's season from ¥50,000)
- NUMBER OF ROOMS: 5
- BATHING: 1 half-outdoor hot spring (can be reserved); 1 family bath (can be reserved)
- CHECK-IN: 3:00 p.m./CHECK-OUT: 10:30 a.m.
- ACCESS:
 CAR: 50 minutes from Tomei Highway, Numazu Interchange or Atsugi Interchange.
 TRAIN: Tokaido Shinkansen Line to Atami, then 20 minutes by taxi; or Odoriko Line to Yugawara Station, then 8 minutes by taxi; or board a Okuyugawara-bound bus from Yugawara Station and get off at Okuyugawara, and then walk 2 minutes.

At this inn, originally designed by the owner to entertain guests for tea, the utmost attention is paid to detail. The spirit of the Japanese tea ceremony permeates the place, and a unified aesthetic sensibility is visible everywhere. The cooking is the object of the same passion for detail. Fresh foodstuffs are delivered from all over Japan for the guests' enjoyment (p. 77). Eating at the counter is also fun. The cook times the food preparation with the pace of your eating; giving you the impression that your very breathing is synchronized. The inn is cozy as well as luxurious.

PARK HYATT TOKYO (78-83)

- LOCATION: Tokyo-to, Shinjuku-ku, Nishi-Shinjuku 3-7-1-2
- PHONE: 03-5322-1234/FAX: 03-5322-1288
- RATES: ¥48,000~¥500,000 (Double-occupancy room. Taxes not included.)
- NUMBER OF ROOMS: 178
- BATHING: Bath in each room, spa (pay).
- CHECK-IN: 1:00 p.m.(3:00 p.m. weekends and before holidays)/CHECK-OUT: 12:00 Noon
- ACCESS:
 CAR: 3 minutes from Shuto Expressway, Shinjuku Interchange.
 TRAIN: 5 minutes by taxi from JR Shinjuku Station.
 LIMOUSINE: Departs directly from Narita and Haneda Airports (not complimentary).
- E-MAIL: mail@parkhyatttokyo.com

The modern lighting creates a wondrous environment. Delicate touches, like Japanese paper lamps in the bedrooms, make you forget that you are in a skyscraper in the middle of Tokyo (p. 80). You are also afforded a clear view of Mt. Fuji in the distance, a rare treat in this city. From the bathrooms in the suites to the pool in the fitness club, water is handled elegantly (p. 83). It's a little startling to look down at Tokyo while taking a bath, though. Albeit a skyscraper, this hotel has plenty of magic.

SHIMA KANKO HOTEL (84-91)

- LOCATION: Mie Prefecture, Shima-gun Ago-cho, Kashikojima
- PHONE: 0599-43-1211/FAX: 0599-43-3538
- RATES: ¥18,000~150,000 (Double-occupancy room. Taxes not included.)
 ¥25,000~¥50,000 (Per person for double-occupancy room w/two meals included. Taxes not included.)
- NUMBER OF ROOMS: 200
- BATHING: Bath in all rooms.
- CHECK-IN: 2:00 p.m./CHECK-OUT: 11:00 a.m.
- ACCESS:
 CAR: 40 minutes from Ise Highway, Ise Nishi Interchange.
 TRAIN: Kintetsu Shima Line, Kashikojima Station, 5-minute walk or 2 minutes by shuttle (3 an hour at 10, 30 and 50 minutes past the hour from 13:00~19:00).
- HOMEPAGE: http://www2.mint.or.jp/~skh-ms/
- E-MAIL: skh-ms@mint.or.jp

Ise Shrine is a popular destination for older people. It's a place I would like to take my parents on vacation. These pictures were shot on my first visit. I was surprised by the massive Japanese cedar rising out of the middle of the shrine path (p. 86). The ancient trees, the silent depths of the forest, and the shrine itself all make for a mysterious yet invigorating atmosphere. Famous French chef Tadayuki Takahashi pursues his art at the Shima Kanko Hotel. I had heard rumors of his creations before, but he still managed to impress me!

EDOSAN (92-97)

- LOCATION: Nara Prefecture, Nara-shi Takabatake-cho 1167
- PHONE: 0742-26-2662/FAX: 0742-26-2663
- RATES: ¥18,000~¥21,000 (Per person for double-occupancy room w/two meals included. Taxes not included.)
- NUMBER OF ROOMS: 5 (all annex rooms)
- BATHING: 2 family baths (can be reserved).
- CHECK-IN: 3:00 p.m./CHECK-OUT: 10:00 a.m.
- ACCESS:
 CAR: 20 minutes from Dai Ni Hanna Doro, Horai Interchange.
 TRAIN: Kintetsu Line, Kintetsu Nara Station, then 15-minutes on foot or 5-minutes by taxi.

Nara at the time of the Bon Festival is indeed a special place. The window of the Great Buddha Hall at Todai Temple is only opened during the festival and at the New Year (p. 93). Several thousand lanterns are lit at Kasuga Shrine during the Festival of Ten Thousand Lanterns (p. 92). A spirit of solemnity presides. The Edosan Inn is itself the height of Japanese architecture. From a stone lantern to a traditional fish carving (p. 97), it is filled with details that draw the eye. Once I caught a deer napping under the tree just outside the guest rooms (p. 96). A nearby park is a continuation of the mountain forest to which the Kasuga shrine is dedicated, so the presence of the trees is powerfully felt at this inn, as well as at the nearby temples and shrines. One feels honored to stay in such a place. Now I understand why famous figures of old, such as Naoya Shiga and Tsuguharu Fujita, took lodgings here, as well as contemporaries like fashion designer Issey Miyake. This comfortable inn quickly feels like home, and is the perfect place to rest after a visit to Nara's ancient temples.

TAWARAYA RYOKAN (98-109)

- LOCATION: Kyoto-fu, Kyoto-shi Nakagyo-ku Fuya-cho, Aneyakoji Agaru
- PHONE: 075-211-5566/FAX: 075-211-2204
- RATES: ¥35,000~¥75,000 (Per person for double-occupancy room w/two meals included. Taxes not included.)
- NUMBER OF ROOMS: 18
- BATHING: Baths in all rooms.
- CHECK-IN: 1:00 p.m./CHECK-OUT: 11:00 a.m.
- ACCESS:
 TRAIN: Shinkansen Tokaido Line, Kyoto Station, then 15 minutes by taxi.

This is probably the most cultured inn in Japan. I wanted to come here ever since I heard that India's maharani fell in love with it. The gardens and the attention to detail throughout are outstanding. I don't think any more perfect embodiment of the Japanese sensibility exists. Everything is a picture of perfection. The gardens are a crucial element contributing to this quality. From the gardens to the woodwork of the building itself, the Japanese affinity with trees is nowhere absent. Trees, earth, and water are all placed with the most refined artistry, subtly influencing the atmosphere. The interiors also change over the course of the year, further deepening your appreciation of the significance of seasonal changes to the Japanese. Fine amenities are also part of the experience. I was particularly impressed by the Firefly Suite; although a new addition, it blends in perfectly (p. 100). After visiting the temples and shrines of Kyoto, a stay in this inn rounds out your experience of the beauty of Japan. I can't imagine anything better.

MACCARINA (110-115)

- LOCATION: Hokkaido, Abuta-gun, Makkari-mura, Aza Midorioka 172-3
- PHONE: 0136-48-2100/FAX: 0136-45-2241
- RATES: ¥35,000~¥40,000 Open Thursday through Monday from June through October (daily July 19 through September 30 and during the New Year's season); weekends only the rest of the year. (Double-occupancy room w/two meals included. Taxes not included.)
- NUMBER OF ROOMS: 4
- BATHING: Hot springs nearby/baths in all rooms.
- CHECK-IN: 3:00 p.m./CHECK-OUT: 12:00 Noon
- ACCESS:
 CAR: Take the Dodo Iwauchi Toya Highway to Makkari Village. Five minutes from there.
 TRAIN: Hakodate Main Line to Kutchan Station, then 30 minutes by taxi.

This inn was decorated by world-famous graphic designer Ikko Tanaka, and it shows in the rooms' simple elegance. The location at the foot of remote Mt. Yotei in Hokkaido is also unique (p. 110). The food is unusually good—vigorous, and visually pleasing. The vitality of the freshly-picked local ingredients shines through. Mountain vegetables play the main role. I had no idea they could be so sweet. I felt as though I was directly ingesting the energy of the sun and the earth. I visited in the middle of September, but the mountain ash trees were already a deep red (p. 113). The cuisine and the changing foliage make this a perfect place to experience the turn of the seasons.

NIKKO KANAYA HOTEL (116-123)

- LOCATION: Tochigi Prefecture, Nikko-shi, Kamihatsu Ishi-machi 1300
- PHONE: 0288-54-0001/FAX: 0288-53-2487
- RATES: ¥12,000~¥40,000 (Double-occupancy room, no meals. Taxes not included.)
 ¥15,500~¥30,000 (Per person for double-occupancy room w/two meals included. Taxes not included.)
- NUMBER OF ROOMS: 76
- BATHING: Baths in most rooms; ¥12,000 rooms have showers only.
- CHECK-IN: 3:00 p.m./CHECK-OUT: 11:00 a.m.
- ACCESS:
 CAR: 5 minutes from Nikko Utsu-no-Miya Doro, Nikko Interchange.
 TRAIN: 5 minutes by taxi from Tobu Line, Tobu Nikko Station or JR Nikko Line, Nikko Station.
- HOMEPAGE: http://www.kanayahotel.co.jp

The waterfalls are the main attraction here. If you visit Kegon Falls in the early morning, you will be treated to a rainbow. At Kirifuri Falls (pp. 118–119), you have the rare experience of looking down at a waterfall. I suggest exploring the Nikko mountains, a World Heritage Site, on foot. Tosho Shrine is marvelous, but I also recommend a look at the Futara Mountain Shrine. At Nikko, each season has its own special flavor, but the fall turning of the leaves is definitely the main event. The bridge over the Daiya River near the Nikko Kanaya Hotel is a unique sight (p. 120). I like the classic ambiance of this hotel, considered a pioneer in Japanese resorts. Viewing the autumn leaves while eating homemade cookies and drinking tea is a luxurious experience indeed. The unique blend of Western and Eastern influences is the legacy of the many years when foreign dignitaries were entertained here. At this hotel, you will feel enveloped in history.

IWASO (124-131)

- LOCATION: Hiroshima Prefecture, Saeki-gun Miyajima-cho, Momijidani
- PHONE: 0829-44-2233/FAX: 0829-44-2230
- RATES: ¥21,000~¥40,000 (Per person for double-occupancy room w/two meals included. Taxes not included.)
- NUMBER OF ROOMS: 42 (including 4 annex rooms)
- BATHING: 2 indoor baths (1 men's and 1 women's); baths in 31 of the rooms.
- CHECK-IN: 3:30 p.m./CHECK-OUT: 10:00 a.m.
- ACCESS:
 CAR: 8 minutes from Sanyo Highway, Hatsukaichi Interchange, or Oono Interchange.
 TRAIN: JR Sanyo Main Line to Miyajimaguchi Station, then a ferry to Miyajima Sanbashi and a 15-minute walk. Complimentary shuttle available 3:00 p.m.~6:00 p.m. (reservations required).
- E-MAIL: miyajima@iwaso.com

Protected by the Itsukushima Shrine, Miyajima Island's forests remain pristine. When the leaves begin to burn with autumn's fires, I think it's safe to say there's no place in the world more inspiring. Red and yellow gradations form complex patterns radiating out from the trees nearest the river. Observing scenery like this from the window of an equally grand hotel is indeed a luxury. It was a pleasant surprise to discover a deer outside the hotel in the early morning (p. 125). The island teems with visitors during the day, but returns to a state of serenity when the lanterns are lit in the evening (p. 126). It's after dusk that you begin to feel the sacredness of the place. I still recall the vivid red leaves right outside the annex room; they seemed worthy of framing.

WASURE-NO-SATO GAJOEN (132-137)

- LOCATION: Kagoshima Prefecture, Aira-gun Makizono-cho, Shuku-kubota 4230
- PHONE: 0995-77-2114/FAX: 0995-77-2203
- RATES: ¥20,000~¥50,000 (Per person for double-occupancy room w/two meals included. Taxes not included.)
- NUMBER OF ROOMS: 10 (with 6 annex rooms)
- BATHING: 2 indoor hot springs (1 men's, 1 women's); 1 outdoor hot spring (mixed); one "waterfall" hot spring (can be reserved); 7 of the rooms have private outdoor baths.
- CHECK-IN: 1:00 p.m./CHECK-OUT: 12:00 Noon
- ACCESS:
 CAR: 15 minutes from Kyushu Highway, Mizube Kagoshima Airport Interchange.
 TRAIN: 20 minutes by taxi from Nippo Main Line, Hayato Station.
 PLANE: 15 minutes by taxi from Kagoshima Airport.

The bathtub cut from a single rock (pp. 134-135) looks anything but refined, but the surface is surprisingly smooth to the skin. From this unique bathtub to the beer awaiting you when you get out (p. 137), as well as the unobtrusively rebuilt old farmhouse, you can divine the good taste of the owners. The food is also charming. The locally gathered produce (p. 137) is delicious, but it's the rice prepared over an open fire that truly warms the heart. I was surprised at the unique flavor this cooking method bestows upon this Japanese staple. With a rooster wandering around the grounds and smoke rising from the kitchen chimney, you'll feel instantly at home here. It's funny how such things whet your appetite and make the food taste even better.

TSUTA ONSEN RYOKAN (138-143)

- LOCATION: Aomori Prefecture, Kamikita-gun Towadako-cho, Tsuta Onsen
- PHONE: 0176-74-2311/FAX: 0176-74-2244
- RATES: ¥10,000~¥32,000 (Per person for double-occupancy room w/two meals included. Taxes not included.)
- NUMBER OF ROOMS: 50
- BATHING: 3 indoor hot springs (2 men's and 1 women's); baths in 4 rooms.
- CHECK-IN: 2:00 p.m./CHECK-OUT: 10:00 a.m.
- ACCESS:
 CAR: 90 minutes from Towada Interchange, Kosaka Interchange, or 70 minutes from Kuroishi Interchange.
 TRAIN: April 1~November 20: Tohoku Main Line to Aomori Station, then board Towada Lake-bound bus to Tsuta Onsen. Winter: Towato Kanko Dentetsu Line to Towada City Station, then board the bus for Yakeyama. Complimentary shuttle leaves from Yakeyama (reservation required).

This inn is a single building located on the edge of Tsuta Swamp (pp. 138–139). I love walking around the variety of natural surroundings here—from Lake Towado to Okuirese to Mt. Hakkoda—then relaxing in the waters of the hot spring that rises up beneath the building. I particularly enjoyed sitting in Senkyo (p. 141) while the hot spring waters burbled between the beech planks beneath me. It made me feel as if I was directly absorbing the energy of the earth itself. Along with poet Keigetsu Oomachi and photographer Shinzo Fukuhara, I consider myself one of this inn's staunchest admirers. The surrounding pristine beech forest gives the inn a mystical air. Although I like the flavor of the gnarled, knotted wood pillars and the toko-no-ma alcove in the old-fashioned rooms (p. 142), the newer rooms of the annex are also comfortable.

SANSO KYOYAMATO (144-149)

- LOCATION: Kyoto-fu, Kyoto-shi Higashiyama-ku, Kodaiji Minamimon-dori
- PHONE: 075-525-1555/FAX: 075-541-1127
- RATES: ¥45,000 and up (Per person for double-occupancy room w/two meals included. Taxes not included.)
- NUMBER OF ROOMS: 15 (5 bedrooms and 10 dining rooms)
- BATHING: 1 family bath (can be reserved).
- CHECK-IN: 2:00 p.m./CHECK-OUT: 11:00 a.m.
- ACCESS:
 CAR: 20 minutes from Kyoto South or Kyoto East Interchange.
 TRAIN: Tokaido Shinkansen Line to Kyoto Station, 15 minutes by taxi.
- HOMEPAGE: http://www01.u-page.so-net.ne.jp/df6/k/sakagt

This inn was originally a restaurant. The huge 10,000-square-meter garden, the teahouse within, the heavy wisteria vines, and the distinctive architecture all contribute to a characteristic Kyoto feeling. The view from the plateau is spectacular. The approach to the entrance of the inn is so bewitching you may find yourself not wanting to go inside! These lodgings have a daunting history: they include a room where warlord Toyotomi Hideyoshi dined, as well as the Soyotei Room, where supporters of the emperor held secret meetings before the Meiji Restoration. Although the lavish accommodations epitomize the height of Kyoto luxury and style, they don't make you uncomfortable. Indeed, the views of the well-tended gardens and the precisely prepared rooms are all somehow very relaxing.

MIYAMA-SO (150-153)

- LOCATION: Kyoto-fu, Kyoto-shi Sakyo-ku, Hanase Harachi-cho 375
- PHONE: 075-746-0231/FAX: 075-746-0233
- RATES: ¥35,000~¥45,000 (Per person for double-occupancy room w/two meals included. Taxes not included. Capacity of four parties per night.)
- NUMBER OF ROOMS: 9 (with 5 annex rooms)
- BATHING: 2 family baths (can be reserved).
- CHECK-IN: 3:00 p.m./CHECK-OUT: 11:00 a.m.
- ACCESS:
 TRAIN: Take subway to Kitaoji Station, then 50 minutes by taxi.
 BUS: Board Hirogawara-bound bus from Demachiyanagi, get off at Daihizanguchi, and take the complimentary shuttle (reservations required).

Having left Kyoto behind, and after navigating the windy Hanase Pass, just as you begin to wonder what you are doing so far away from the city, you reach the inn. This is the first time I've been treated to tsumikusa (wild vegetable) cuisine (p. 150), which includes the pictured iwatake mushrooms and mukago potatoes. They were so fresh I felt as though I was eating a living part of the mountain! I was also pleasantly surprised by the delicious flavor of the wild carp. Such food could only be offered here. The preparation of the rooms, including the fusuma painting by Todai Temple artist Kosho Shimizu (p. 153), is full of nice touches. Since the inn is deep in the mountains, hand-warmers (p. 151) and hibachi (p. 153) make you feel all the more cozy.

KAMENOI BESSO (154-159)

- LOCATION: Oita Prefecture, Oita-gun Yufuin-cho Kawakami
- PHONE: 0977-84-3166/FAX: 0977-84-2356
- RATES: ¥30,000~¥40,000 (Per person for double-occupancy room w/two meals included. Taxes not included.)
- NUMBER OF ROOMS: 21 (with 15 annex rooms)
- BATHING: 2 indoor hot springs (1 men's and 1 women's); 2 outdoor hot springs (1 men's and 1 women's); hot spring-fed baths in each room.
- CHECK-IN: 3:00 p.m./CHECK-OUT: 11:00 a.m.
- ACCESS:
 TRAIN: Kyudai Main Line to Yufuin Station, then 4 minutes by taxi.
 PLANE: Bus to Beppu from Oita Airport (40 minutes), then 40 minutes by taxi or 60-minute bus ride from Beppu.

This inn has the magical quality of making you feel as if you've been here a hundred times before, even on your first visit. It's hardly gaudy, but you'll feel as if you are relaxing in a mountain retreat which was built sparing no expense. Some of the trees in the 30,000-square-meter grounds are hundreds of years old. Thus, the inn seems to be in the middle of a forest rather than surrounded by a garden. It's pleasant to walk around the pond, Kinrinko, right in front, and there's a lot to see in the resort town of Yufuin as well. The hot springs here are marvelous. The big bathhouse and the outdoor hot springs (p. 155) are inviting, but since the hot spring waters are fed into each room, you can spend as much time as you like in your own private bath. The lounge with a fireplace is cozy as well (p. 159). The bountiful cuisine of Kyushu is given treatment above reproach. The design of each room is individualized, especially the annex rooms. One wants to spend more than a day or two relaxing at this adult retreat. Four or five seem more appropriate.

IWAIYA (160-165)

- LOCATION: Tottori Prefecture, Iwami-gun Iwami-cho, Iwai Onsen
- PHONE: 0857-72-1525/FAX: 0857-73-0123
- RATES: ¥15,000~¥23,000 (Per person for double-occupancy room w/two meals included. Taxes not included.)
- NUMBER OF ROOMS: 18
- BATHING: 2 outdoor hot springs (1 large/1 small, men and women alternate); 1 outdoor hot spring (men and women switch); family bath (can be reserved); baths in 2 rooms.
- CHECK-IN: 3:00 p.m./CHECK-OUT: 10:30 a.m.
- ACCESS:
 CAR: 120 minutes from Chugoku Highway, Sayo Interchange or Fukuzaki Interchange.
 TRAIN: 5 minutes by taxi from San'in Main Line, Iwami Station.
 PLANE: 30 minutes by taxi from Tottori Airport.

This place was recommended to me by the locals. You can eat all the Matsuba crab you want here. Roasted crab, boiled crab, crab shabu-shabu…I had no idea there were so many ways to eat crab! This was also where I learned that Matsuba ("pine needle") crab gets its name from the manner in which the crustacean bursts open when cooked (pp. 162-163). The Sanin Coast is brutally cold during winter, but if you can stand it, the Tottori Sand Dunes, covered in a thin layer of snow, and the Sanin Cliff—both painted by Kaii Higashiyama—are a picturesque and bewitching sight (pp. 160-161). Walking through the cold wind you encounter this pleasant hot spring and inn, where you can warm yourself and relax in a refined atmosphere.

ARAYA TOTOAN (166-169)

- LOCATION: Ishikawa Prefecture Kaga-shi, Yamashiro Onsen, Yu-no-Gawa
- PHONE: 0761-77-0010/FAX: 0761-77-0008
- RATES: ¥28,000~¥50,000 (Per person for double-occupancy room w/two meals included. Taxes not included.)
- NUMBER OF ROOMS: 20
- BATHING: 2 indoor hot springs (1 men's and 1 women's); 1 outdoor hot spring (men and women switch); baths in all rooms.
- CHECK-IN: 2:00 p.m./CHECK-OUT: 11:00 a.m.
- ACCESS:
 CAR: 15 minutes from Hokuriku Highway, Kaga Interchange.
 TRAIN: Hokuriku Main Line to Kaga Onsen Station, 7 minutes by taxi.
 PLANE: 20 minutes by taxi from Komatsu Airport.
 BUS: Board Yamashiro Onsen-bound bus from Kaga Onsen Station or Komatsu Airport and get off at Yamashiro Onsen Higashiguchi, then walk 5 minutes.
- HOMEPAGE: http://www.araya-totoan.com/
- E-MAIL: info@araya-totoan.com

I wanted to visit this inn ever since I learned that Rosanjin stayed here. Rosanjin was a strong-willed artist who lived an extraordinary life, and I've always admired him. Near the inn is the famous Seika Suda kiln; an expedition in search of pottery is a must. Araya boasts many works of pottery by the first Seika Suda, from whom Rosanjin learnt the craft. Many of Rosanjin's works are also kept in the collection at Araya, and are fascinating indeed (p. 168). The inn's cuisine features exquisitely prepared seafood and vegetables (p. 169), which I'm sure is part of what drew Rosanjin in the first place.

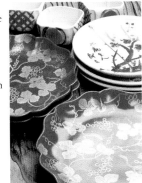

YUMEYA (170-177)

- LOCATION: Niigata Prefecture, Nishi Kanbara-gun Iwamuro-mura, Ooaza Iwamuro 905-1
- PHONE: 0256-82-5151/FAX: 0256-82-5153
- RATES: ¥29,800~¥40,000 (Per person for double-occupancy room w/two meals included. Taxes not included.)
- NUMBER OF ROOMS: 10
- BATHING: 2 indoor hot springs (1 men's and 1 women's); 2 outdoor hot springs (1 men's and 1 women's); baths in all rooms.
- CHECK-IN: 2:00 p.m./CHECK-OUT: 11:00 a.m.
- ACCESS:
 CAR: 30 minutes from Hokuriku Highway, Sanjo Tsubame Interchange.
 TRAIN: Joetsu Shinkansen Line to Tsubame Sanjo Station, then 30 minutes by taxi.
- E-MAIL: yumeya@rose.ocn.ne.jp

I was born on the southern island of Shikoku, so I appreciated getting a peek at life in the snow country. The wide expanse of rice fields were covered in a blanket of snow when I visited (p. 171), but I'm sure that they glow bright gold in the autumn. I've never seen such large expanses of snow before. Yumeya is immaculately clean, so guests are encouraged to go barefoot; this made me foolishly happy, as did the opportunity to bath in hot springs while gazing at the snow (p. 176). The warm glow of the inn combined with a gin-and-tonic warmed my bones amidst a world of blue-white snow.

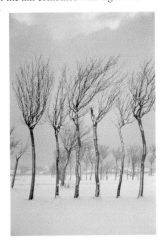

HAKKODA HOTEL (178-186)

- LOCATION: Aomori Prefecture, Aomori-shi Hakkodasan 1
- PHONE: 017-728-2000/FAX: 017-728-1800
- RATES: ¥28,000~¥42,000 (Per person for double-occupancy room w/two meals included. Taxes not included.)
 ¥32,000~¥60,000 (Double-occupancy room; no meals. Taxes not included.)
- NUMBER OF ROOMS: 55
- BATHING: 2 indoor hot springs (1 men's and 1 women's); baths in all rooms, 3 minutes by car to affiliated Sukayu hot spring.
- CHECK-IN: 12:00 Noon/CHECK-OUT: 11:00 a.m.
- ACCESS:
 CAR: 50 minutes from Tohoku Highway, Aomori Interchange.
 TRAIN: Tohoku Main Line to Aomori Station, then 50 minutes by taxi. Or board Towadako-bound bus from Aomori Station and get off at Sukayu Onsen. 3 minutes by complimentary shuttle from there (reservation required).
 PLANE: 50 minutes by taxi from Aomori Airport.

I took a trip to Hakkoda Mountain to view the frosted tree branches. You can't get any deeper into the snow country in winter than this. Roads are closed beyond the inn. One look at the street lamps buried in snow (p. 180) and you'll be convinced you wouldn't want to go any further anyway. The bitter cold of winter pierced me to the bone. Paintings by Shiko Munakata hang here and there in this mountain lodge (p. 182). Eating haute French cuisine while surrounded by such daunting snowdrifts makes you feel as if you are in northern Europe. Sukayu Hot Springs, affiliated with the hotel, is just a stone's throw away. There they have the Thousand Man Bath, the largest indoor hot springs I've ever seen (pp. 184-185). The waters are thick with the earth's minerals, and the steam is so dense that light doesn't penetrate, making for an almost mystical bathing experience. After warming myself in the bath, I saw snowflakes with crystals so large I could make them out with the naked eye.

MAP OF LODGINGS